IMAGES
of America

EARLY SAN RAFAEL

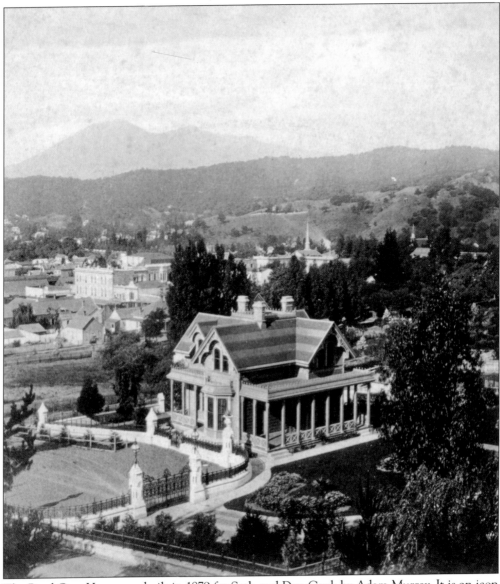

The Boyd Gate House was built in 1879 for Seth and Dan Cook by Adam Murray. It is an icon of Gothic Revival architecture and is a state and national landmark. The Gate House and Boyd Park, which were inherited by Louise Arner Boyd from the Cooks, were given to the City of San Rafael in 1905 as a memorial to the deceased young sons of Louise and John Boyd. The Marin History Museum has occupied the Gate House since 1955. (Courtesy Marin History Museum.)

ON THE COVER: Fourth Street is a blend of rusticity and sophistication in this 1900 photograph. Looking west from A Street, horse-drawn wagons travel the unpaved street. (Courtesy Marin History Museum.)

IMAGES
of America

EARLY SAN RAFAEL

Marin History Museum

ARCADIA
PUBLISHING

Published by Arcadia Publishing
Charleston SC, Chicago IL, Portsmouth NH, San Francisco CA

Printed in the United States of America

Library of Congress Catalog Card Number: 2008922701

For all general information contact Arcadia Publishing at:
Telephone 843-853-2070
Fax 843-853-0044
E-mail sales@arcadiapublishing.com
For customer service and orders:
Toll-Free 1-888-313-2665

Visit us on the Internet at www.arcadiapublishing.com

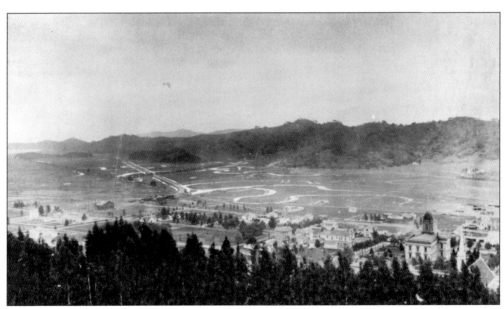

The Marin County Courthouse rises in the lower right of this 1882 panorama of San Rafael. The salt marshes, broken by meandering sloughs and inlets, are evident in the area south and east of the city. (Courtesy Marin History Museum.)

CONTENTS

ACKNOWLEDGMENTS

The Marin History Museum would like to acknowledge and thank Judy Coy and Jocelyn Moss for the energy that they brought to the creation of this book. They volunteered their time and expertise to select photographs, research, and write about San Rafael.

Without the donations of photographic materials by many local residents and the work of historians, past and present, this book would not have been possible. Among those who contributed source materials on the history of San Rafael are Bill Allen, Lionel Ashcroft, Florence Donnelly, Betty Goerke, Frank Keegan, Dewey Livingston, Ken McCready, Jack Mason, Barry Spitz, and Marilyn Wick. Their research and writings paved the way.

The staff of the Marin History Museum was generous with their time in assisting with the project. Laurie Thompson and Carol Urmacher of the Anne T. Kent California Room of the Civic Center Branch of the Marin County Free Library were ever helpful with research. Michael Peterson of the San Francisco Theological Seminary and Charles Kennard graciously provided photographs. Unless otherwise indicated, all images used in this book are from the collection of the Marin History Museum.

INTRODUCTION

San Rafael is in a lovely valley surrounded by hills with a meandering creek winding down to San Francisco Bay. The native Coast Miwok took notice of all the advantages of the location, calling their settlement near the creek Nanaguani. The wooded hills provided game to eat as well as oak trees from which they harvested acorns for meal. The marshlands near the bay sheltered ducks and other waterfowl. Shellfish were plentiful in the bay. All the gifts of nature provided a paradise for the native dwellers in San Rafael.

The mission fathers founded Mission Dolores in San Francisco in 1776, but they found the climate did not agree with the Native Americans who were gathered into the mission as a workforce. The fathers set out to find a place with a better climate in hopes of curing the sick and dying Native Americans. They found San Rafael and were immediately attracted to the healthy climate and abundance of natural resources. Led by Father Luis Gil y Taboada, Mission San Rafael Arcangel was established as an *asistencia*, or hospital, to Mission Dolores on December 14, 1817. Many of the Native Americans were brought to the new mission, the land was fruitful, and livestock multiplied. In 1822, Mission San Rafael became a full mission, the 20th in the chain of 21 missions. After the Mexican government took over from Spain, the rich lands of the missions were coveted by the settlers. The missions were secularized, and the lands were given away or sold. The end of Mission San Rafael came in 1834.

The Mexican government divided what was later to become Marin County into 21 land grants, which were given for service or favors to Mexican citizens. Timothy Murphy, a hearty Irishman, received a huge land grant surrounding the pueblo San Rafael. The grant, San Pedro, Santa Margarita y Las Gallinas, was given to him for his work in dividing the assets of Mission San Rafael and distributing the cattle and other livestock to the Native Americans. San Rafael basked in the warm sun for a short time, enlivened by festivities around San Rafael Day, weddings, and rodeos near the mission. But when the Mexican War ended in 1848 and the United States took over, huge changes were in store for the little village.

With the discovery of gold, immigrants from around the world flocked into the gold fields. Although there was no gold in Marin County, there were weary miners who sought other products in the hills and valleys. The redwood trees were eyed for a source of lumber for San Francisco. San Francisco's population was exploding, and the trees of Marin provided the building materials for homes, hotels, and businesses. Land speculators saw the huge land grants as ripe for real estate speculation. The hills of Marin were perfect for the dairy industry.

When California became a state, Marin County was one of the first counties created, and San Rafael was named the county seat. Gold Rush immigrants took over the county government jobs and laid out the town. Speculation in land was the main business of the time. Those who did not make money in the Gold Rush sought to make a profit in real estate.

William T. Coleman was attracted to the beauty of the area and its potential for development. He bought a huge tract of land east of the city and began developing it for country estates. He built roads and planted trees in what is now the Dominican area of San Rafael. The climate was

a major attraction to San Franciscans who wanted a healthy place to raise a family. Coleman pushed for a reliable water supply, rail service, and a luxury hotel. All his dreams came to fruition. San Rafael woke up and built an imposing courthouse. The population grew, and San Rafael incorporated, the first city in Marin to do so.

San Rafael's healthy climate attracted two military academies and the Dominican Sisters, who built a school for girls. There were three newspapers to inform the populous, and a library was started as an alternative to the many bars on Fourth Street.

In the early 1900s, moving pictures made their appearance in San Rafael, and the California Moving Picture Corporation moved into town. This created quite a stir among the local residents, but they became used to seeing the star Beatriz Michelena strolling down Fourth Street with her Russian Wolfhounds. Several movies were made before the company closed. Though the enterprise was short-lived, it remained for years in the memory of the old-timers.

The city of San Rafael gained its first park in 1905 when Boyd Memorial Park was donated. Following this example, other parks were established. The city boasted a municipal bathhouse where the famous Olympic swimmer Eleanor Garatti trained.

Many important people found San Rafael a good choice for their residence. There was Leon Douglass, the inventor; Robert Dollar, the entrepreneur; and Louise Boyd, the Arctic explorer.

San Rafael did not welcome the automobile at first, but in time, it took over the roads. Improvements had to be made in the city streets to accommodate this new invention. Soon there was talk of a bridge across the Golden Gate. This was another bonanza for real estate development as the commute to San Francisco became easier than ever. Everyone looked forward to the population explosion that the new Golden Gate Bridge would bring.

The authors hope everyone enjoys this peek into the history of San Rafael up to the time of the opening of the Golden Gate Bridge. Most of images in this book are from the collection of the Marin History Museum, which has preserved photographs, newspapers, artifacts, and manuscript materials since its founding in 1935. Many local families have entrusted their family memorabilia to the museum. Today the museum holds the richest collection of photographs of Marin County and is still actively collecting. The Marin History Museum is open to all to view the exhibits there or to research the history of a Marin County home or resident.

One

NANAGUANI

San Rafael is situated in a beautiful, warm, sunny valley. This valley is surrounded on all sides, except to the east, by oak-studded hills. San Rafael Ridge runs from Point San Quentin to San Anselmo and provides protection from the coastal fog and wind. Mount Tamalpais is visible from the valley floor. San Rafael Hill rises to 710 feet and protects the valley from the northern winds. Natural springs flow from the hill, providing a source of fresh water. Water flows from San Pablo and Suisun Bays and the San Joaquin and Sacramento Rivers through San Pablo Straits to the east. San Rafael Bay, bounded by Point San Quentin and Point San Pedro, leads into the San Rafael Creek estuary.

The archeological record shows that the Coast Miwok saw all of the advantages of this location. They inhabited the area for thousands of years prior to the arrival of Europeans in Marin, calling their village along San Rafael Creek Nanaguani. The tribe of Coast Miwok in this area of Marin County was the Aguasto.

The Coast Miwok were hunters and gathers who judiciously tended their environment to increase its productivity, their lives intimately linked to the changing seasons. The valley and its surrounding hills and bay provided an abundance of food. In the wooded hills, elk, deer, rabbits, squirrels, and birds were hunted for food, fur, tools, and ornamentation. The acorns from tan oak and valley oak trees, as well as grass and flower seeds, were harvested and stored for year-round consumption. San Rafael Creek meandered to the bay, and salmon and steelhead were plentiful during their seasonal runs. The extensive marsh, extending south and east from the creek toward the bay, sheltered ducks, geese, and other waterfowl. Shellfish and shrimp were harvested in the shallow waters off Point San Pedro. Willow for baskets and traps and tule for homes and boats grew along the creek.

The Coast Miwok had a rich culture that included fine basket weaving, dances and ceremonies, and a complex language. They were to enjoy this culture in the paradise of Nanaguani until the Spanish began building a network of missions and presidios throughout California. In a short time, the Miwok were to lose their lands and their way of life. In 2007, Greg Sarris, head of the Miwok Tribal Council, said, "The Spanish made us homeless and strangers in our homeland."

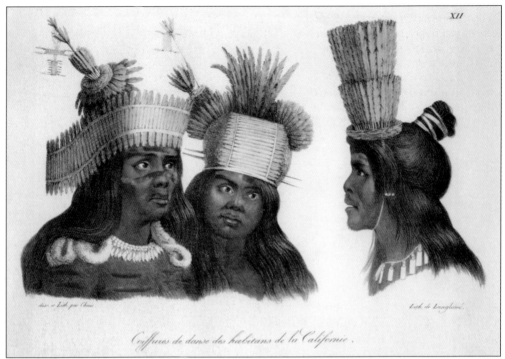

Coiffures de danse des habitans de la Californie.

The headdresses, elaborate constructions of flicker-feather bands and other feathers seen in this 1822 drawing by Russian artist Louis Choris, are representative of those that the Coast Miwok wore for ceremonial dances.

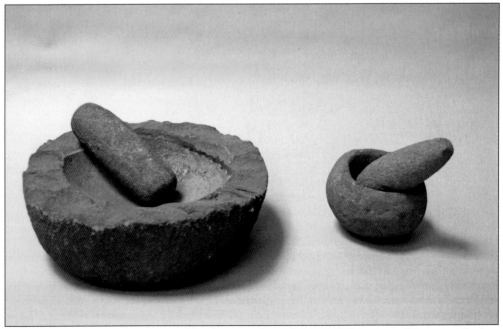

Stone mortars and pestles were used by the Coast Miwok to grind the acorns that were a dietary staple. These mortars and pestles, from the Marin History Museum Collection, were found in Marin County.

Acorns were gathered in the fall and were stored in granaries. California bay leaves were used to protect the acorns from rodents and insects. This redwood bark granary is at Kule Loklo, an interpretive Coast Miwok village at Bear Valley Visitor Center in Point Reyes National Seashore.

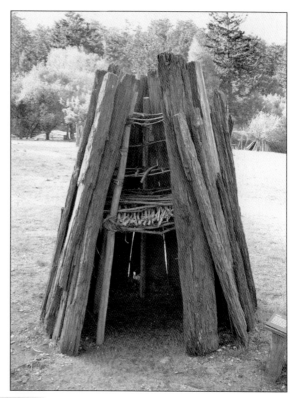

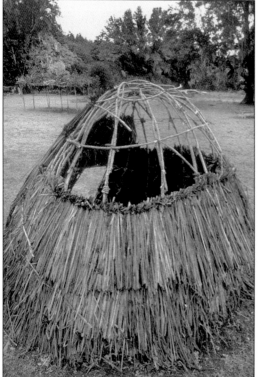

Coast Miwok houses, called *kotcha*, were dome or conical shaped and were commonly made of tule or redwood bark. Tule kotcha, such as the one pictured here at Kule Loklo, were built of bent poles of willow to which were lashed horizontal poles. Bunches of grass or tule were tied in rows to form a thatch on the pole frame. Five or more family members might live in a single large kotcha. (Courtesy Charles Kennard.)

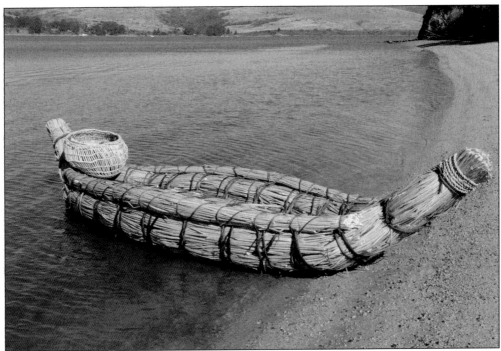

Boats were built of tule that grew along San Rafael Creek and in the surrounding wetlands. Bundles of tule were lashed together with lupine root rope, tule rope, or split tree shoots. The boats were light and buoyant, and could be easily paddled along the creek, shallow shoreline, and across the marshes and bays. The 15.5-foot "double-ender" pictured here was constructed in 2007 by Charles Kennard and his students in a workshop sponsored by the Miwok Archeological Preserve of Marin. The boat is now in the collection of the Oakland Museum. (Courtesy Charles Kennard.)

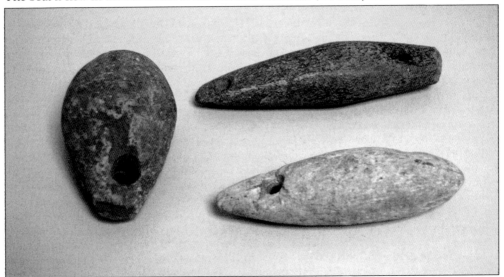

These shaped stones, from the Marin History Museum's collection, are charm stones. Each has a symmetrical hole drilled in the end. It is likely that the Coast Miwok attached thongs to these ritual objects and wore them over the shoulder or around the neck for good luck in fishing and hunting.

Two

MISSION
SAN RAFAEL ARCANGEL

Mission San Rafael Arcangel began its existence as a hospital, or *asistencia*, for Mission Dolores in San Francisco. Disease, brought on by the damp weather, and the harsh conditions of mission life caused a high mortality rate among the Native Americans who had been brought into the mission. Father Luis Gil y Taboado volunteered to establish a hospital mission in Marin, where the drier climate might prove to be better for their health. Fr. Vincente de Sarriá, the prefect, gave his approval.

The new asistencia, founded on December 14, 1817, was named after St. Raphael the Archangel, the angel of bodily healing. The site chosen was on a rise above San Rafael Creek, the place the Coast Miwok called Nanaguani. The location proved to be ideal with a warm, dry climate; good soil; and fresh spring water flowing from San Rafael Hill. By the end of the first year, the asistencia had a population of more than 300. A tile-roofed adobe structure was built, containing a chapel, a room for Father Gil, a guest room, and apartments for the military guards. It was later enlarged with the addition of a chapel, forming an L-shape. In time, other structures were added. Father Gil remained in charge of the asistencia for two years. He was replaced by Fr. Juan Amoros, who taught the Native Americans a variety of trades and expanded the mission economy with crops and cattle. The land was fruitful, the livestock multiplied, and the community grew. As a result, the asistencia in San Rafael was raised to full mission status on October 19, 1822.

Father Amoros died in 1832. In 1833, the Mexican government secularized the missions. Mission San Rafael was the first one to be secularized, and its property was placed under the care of a civil administrator. In 1837, Gen. Mariano Vallejo, military commander for the region, confiscated the equipment and supplies of the mission, including the grapevines and fruit trees, transferring them to his private ranches in the area. Mission San Rafael Arcangel was abandoned; its remaining adobe buildings were demolished in 1861. In 1909, the Native Sons of the Golden West erected a mission bell sign at the site, and in 1949, a replica of the original mission was constructed adjacent to the parish church of St. Raphael on the approximate site of the hospital mission established by Father Gil.

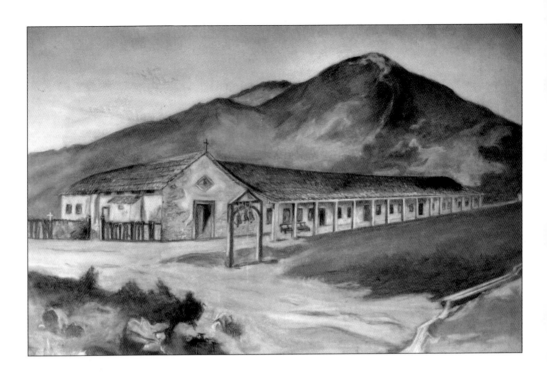

No one knows exactly what Mission San Rafael Arcangel looked like. No paintings or sketches were made during the structure's existence from 1817 to 1861. In 1878, Gen. Mariano Vallejo provided details from memory for the earliest sketch. It depicted a two-story adobe church with a cross on top and a square window over the entrance. Attached to the right of the church were the priests' dwellings. Ten columns supported the covered corridor. A bell was suspended from an L-shaped post. Many artists, including the two whose works are shown here, have since painted pictures of the mission, inspired by their own imaginations or by the works of others.

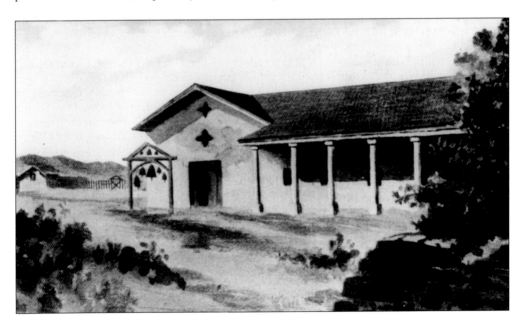

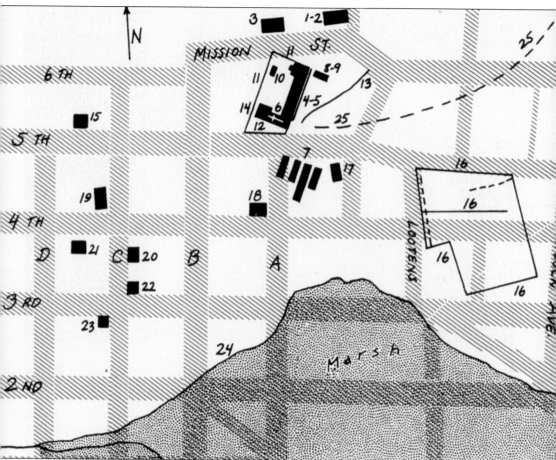

This map, adapted by Marin historian Dewey Livingston from one appearing in G. W. Hendry and J. N. Bowman's *The Spanish and Mexican Adobes and Other Buildings in the Nine San Francisco Bay Counties, 1776 to about 1850* shows the layout of the mission grounds and other early San Rafael buildings. On the map are (Nos. 1 and 2) an adobe dwelling, unknown date; (No. 3) the Walter Skidmore dwelling, the late 1840s; (No. 4) an adobe mission building, 1818 and later; (No. 5) four buildings, 1819; (No. 6) the third adobe mission church, dedicated 1824; (No. 7) six houses for neophytes, 1826; (No. 8) additions to the guest rooms and to the kitchen, 1832; (No. 9) an unknown mission building, the 1830s; (No. 10) an adobe Indian house, the 1830s; (No. 11) the mission adobe walls, the 1820s; (No. 12) the mission cemetery; (No. 13) the mission irrigation ditch; (No. 14) a mission adobe building, the early 1830s; (No. 15) the Charles Lauff dwelling, c. 1850; (No. 16) the adobe walls of the mission orchard and vineyard, the early 1820s; (No. 17) the Short adobe dwelling, the late 1820s; (No. 18) the James Miller dwelling, c. 1849; (No. 19) the Timothy Murphy adobe dwelling, 1839 and later; (No. 20) a building, the late 1840s; (No. 21) the H. Willard (?) Building, c. 1850; (No. 22) a dwelling, c. 1850; (No. 23) a dwelling, c. 1850; (No. 24) the estuary shoreline, 1850; and (No. 25) the road to Sonoma.

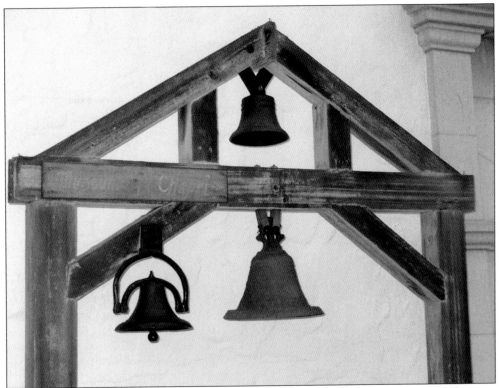

The mission had no bell tower. The first bell, acquired in 1820, hung from a wooden beam. Over the years, three more bells were added. Daily activities in the mission were signaled by the ringing of the bells. With the secularization of the mission, the bells were scattered and lost; ultimately, all four bells were recovered and returned. Pictured here are the three bells that hang today outside of the 1949 mission chapel. They are replicas recast from the originals, which are housed in the mission museum.

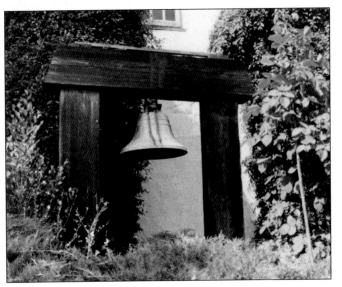

A fourth mission bell, dating from 1829, was found in Sausalito in 1957. In preparation for the 150th anniversary of the mission, the 175-pound bell was hung from redwood beams on the Fifth Avenue side of the chapel. In 1966, it was stolen by students as a prank and was recovered by the San Rafael Police Department. In 1990, it was stolen again and has not been recovered.

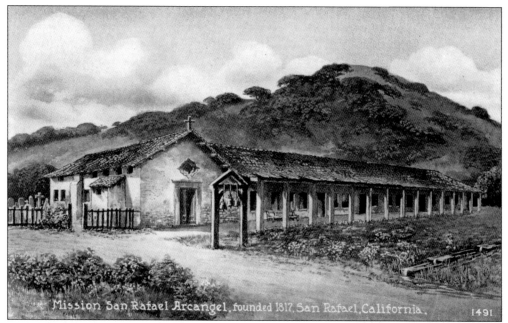

In this depiction of Mission San Rafael Arcangel by artist Felix Adrian Raynaud, water flows in a wooden trough in front of the mission. The site of the mission was chosen in part because of the availability of fresh water flowing from a spring on the side of San Rafael Hill. The mission fathers dug a ditch from the spring down the hill, where the water flowed through the trough and continued on to the mission orchard. Today there are still active springs on the side of San Rafael Hill.

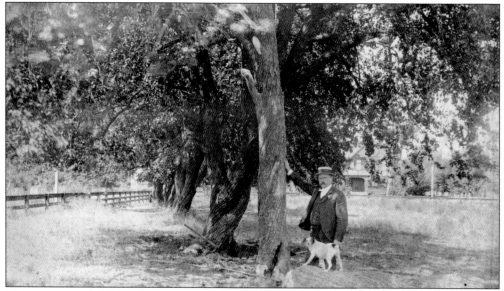

The mission orchard was located approximately a block southeast of the current mission site at Fourth Street and Lootens Place. In this 1911 photograph, an unidentified man and his dog pose with the last remaining pear trees; all but one were bulldozed in 1929. The pear tree, growing today outside the Octagon House at the Marin Art and Garden Center, was grown from a graft of one of these mission pear trees.

17

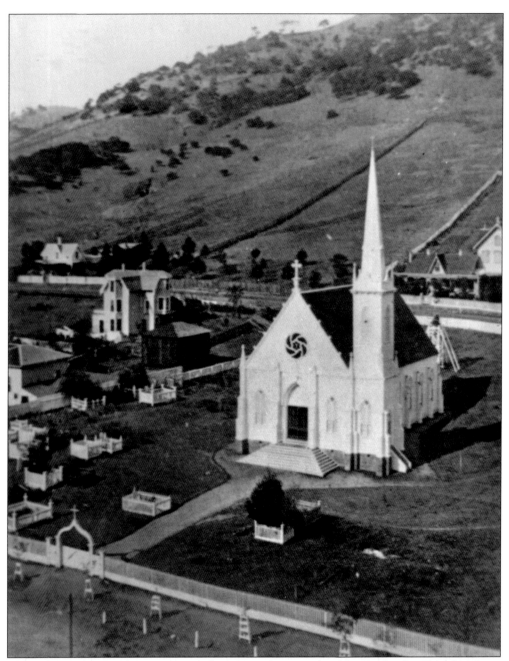

The old mission cemetery is seen in this 1870s photograph of St. Raphael's Church. Marin County's namesake, Chief Marin, was buried here in 1839. Chief Marin was born in a Coast Miwok village in southern Marin around 1780 and was named Huicmuse. He was baptized in 1801 at Mission Delores and was given the name Marino. Eleven years after his death, he was honored for his courage and spirit when General Vallejo named the county after him. In 1885, the marked graves in the cemetery were moved to Mount Olivet Cemetery; the unmarked graves were left in place.

Three

RANCHO DAYS

In 1837, Timothy Murphy was appointed the administrator of Mission San Rafael. Murphy was born in Ireland in 1800 and came to California in 1828. He first worked in the meatpacking industry and then was a successful otter trapper. Murphy was famous for his size and strength, weighing some 300 pounds and standing well over 6 feet tall. In San Rafael, Murphy was also an agent for the 1,400 Native Americans still living on the mission grounds. He learned Coast Miwok and encouraged them to use skills learned at the mission. Under secularization, the converted Miwok were to receive part of the Mission San Rafael lands, and Murphy represented them in their unsuccessful claim for Tinicasia in Nicasio.

In 1839, Murphy became a Mexican citizen, and in 1844, he was granted three contiguous parcels—San Pedro, Santa Margarita, and Las Gallinas—for his services. Life on the rancho was good. Don Timoteo, as Murphy was called, imported greyhounds and Irish setters, expanded his stable of horses, and increased the grazing lands of his livestock. He built a two-story adobe hacienda, which became the center of social life in the little pueblo. Murphy's fiestas were renown, with guests arriving from San Francisco and elsewhere in Marin. In 1847, the first San Rafael Day was celebrated. It became an annual tradition and featured rodeo events, bullfights, gambling, and liquor. But the "days of the dons" were destined to come to an end.

In June 1846, the California Bear Flag replaced the Mexican flag, and a short time later, the Stars and Stripes flew over California. In 1850, California was admitted to the Union as the 31st state. Timothy Murphy died in 1853, and the distribution of his lands shaped the future boundaries of San Rafael. James Miller, another Irishman and Murphy's friend, had previously purchased 680 acres of the Las Gallinas Rancho; Murphy's nephew, John Lucas, inherited the Santa Margarita Rancho; Matthew Murphy, Timothy's brother, inherited the San Pedro Peninsula; and 317 acres were bequeathed to the Catholic Archdiocese for a seminary or institution of learning.

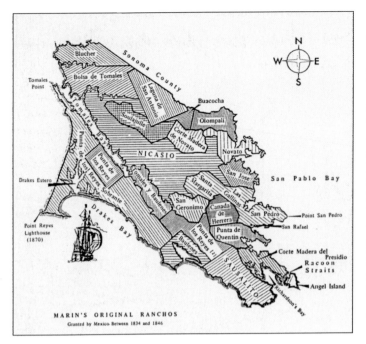

Marin County was divided by the Mexican government into 21 land grants that were awarded for service or favors to Mexican citizens. On February 14, 1844, Timothy Murphy was awarded the three adjoining parcels—San Pedro, Las Gallinas, and Santa Margarita—as one land grant comprising 21,678 acres. The grant included the lands surrounding the pueblo of San Rafael, west to Red Hill, north to Terra Linda, Marinwood and Lucas Valley, and the land east to Point San Pedro.

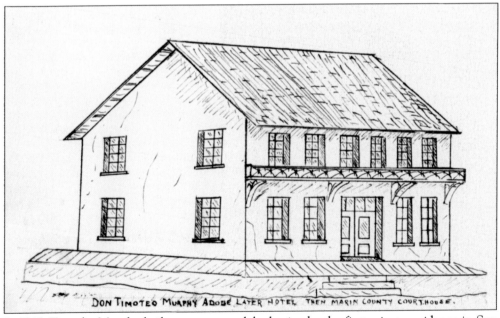

DON TIMOTEO MURPHY ADOBE LATER HOTEL THEN MARIN COUNTY COURTHOUSE.

In 1845, Timothy Murphy built a two-story adobe hacienda, the first private residence in San Rafael. It was located on the northwest corner of Fourth and C Streets. After Murphy's death, the old adobe building served as the Marin County Courthouse for 20 years. This sketch of it was drawn by Louis Peter (1872–1949), a San Rafael businessman and amateur artist.

This document, written in Spanish, bears the signature of Timoteo Murphy as *alcalde*, or mayor, of the pueblo of San Rafael and grants permission to Maria Sanchez, wife of John Reed, to use the cattle brand shown in the margin. The document was entered into in the Book of Brands on September 4, 1845. The Book of Brands is the earliest Marin County official record. It is part of a collection at the Marin History Museum.

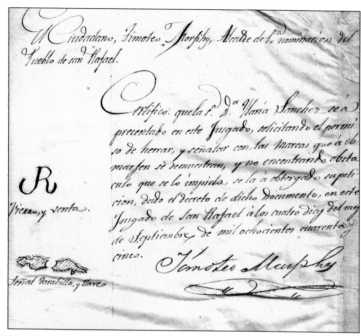

John C. Fremont was not at Sonoma when the Bear Flag was raised, but he was thought to be the instigator of the revolt. He rode south with some of the Bear Flaggers and took over Mission San Rafael. Fremont's involvement in the killing of three unarmed men in San Rafael has been given as the reason why he lost his bid for the U.S. presidency in 1856.

This interesting mural hangs in the lobby of the Mission Rafael Post Office on D Street. The building was dedicated in 1937, and the mural was installed in 1938. It was painted by Oscar Galgiani (1903–1994), a muralist from Stockton. It depicts the boat landing along San Rafael Creek during the days of the mission and the period shortly thereafter. The creek in those days meandered up through marshlands a considerable distance; the landing would have been in the

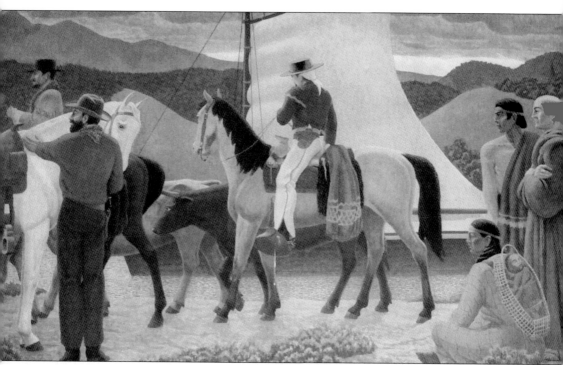

area of present-day Third and A Streets. Mount Tamalpais is in the background. The landing was the probable site where, on June 28, 1846, at the time of the Bear Flag Revolt, Kit Carson, on orders from John C. Fremont, shot and killed Francisco and Ramon de Haro and their uncle Don Jose de los Reyes Berryessa. All three men were unarmed.

John Lucas was the man for whom Lucas Valley Road is named. Lucas, the nephew of Timothy Murphy, came to Marin County in 1852. Murphy had never married and had no children, so he brought his nephew over from Ireland to see if he would like to take up ranching. Lucas liked the looks of Marin County and returned to Ireland to marry his sweetheart, Maria Sweetman. The young couple returned to Marin only to find their uncle had died. The Lucases inherited 7,600 acres of land north of San Rafael in what are now Terra Linda and Marinwood. They built a large home in Terra Linda. Maria ran the ranch because John was too much of a gentleman to deal with such mundane affairs. Nine children were born to the couple, but only six survived infancy. In 1880, the Lucas family donated land to the Archdiocese of San Francisco for Mount Olivet Cemetery. Both John and Maria are buried in the cemetery.

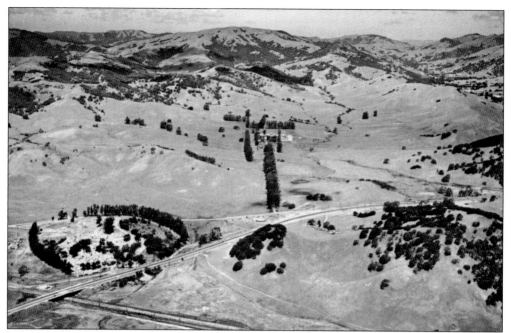

John Lucas built a home on his ranch in 1863 in today's Terra Linda. Manuel Freitas purchased the property in 1898. The ranch house can be seen in this photograph taken prior to development of Terra Linda in the 1950s. The long eucalyptus-lined driveway leads to the house from Highway 101. Mount Olivet Cemetery is in the lower left.

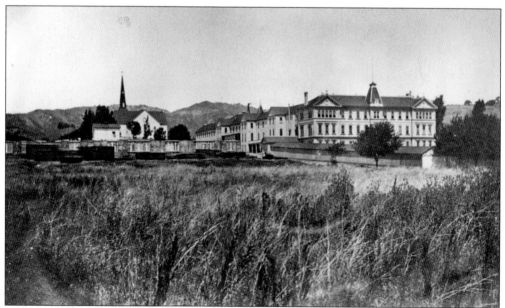

On his deathbed in January 1853, Timothy Murphy donated 317 acres on the northeast corner of his land to the Archdiocese of San Francisco for a school or seminary of learning. What started as a school in 1855 soon became an orphanage for boys. St. Vincent's School for Boys is pictured here in 1878. Today the school is a residential treatment home for boys. It is a registered California Historical Landmark.

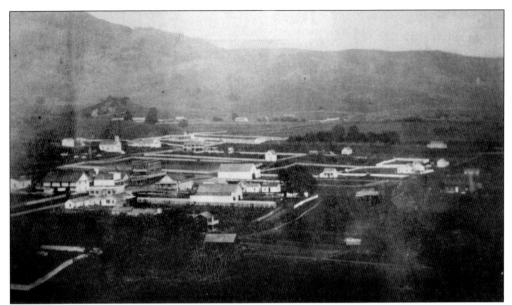

This is the earliest known photograph of San Rafael, dating from around 1862, just nine years after Timothy Murphy's death. The single gable, two-story building in the center on the far left is Murphy's adobe hacienda. The large building to the right of the adobe hacienda is the Hotel Marin, built in 1859 by convict labor from San Quentin. The structure is the oldest commercial building still standing in San Rafael. St. Raphael's Church can be seen in the upper left.

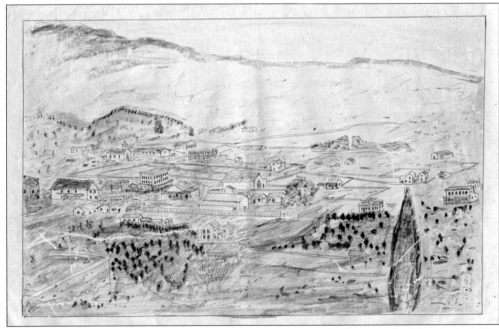

An unknown artist made this drawing based on the above early photograph of San Rafael. The buildings and landmarks can be more readily discerned.

Four

THE PIONEERS

The pioneers of San Rafael and Marin County came from around the world. In the 1840s, there was just a thin trickle of immigrants. They came across the plains in covered wagons or arrived after long ocean voyages. Then, with the discovery of gold in California, the trickle turned into a torrent. In every country there was the cry of "Gold! Gold discovered in California!" Thousands answered the call, eager to reap the wealth. Not all succeeded. There was no gold in Marin County, but some who did not find gold came to San Rafael to find another way to make money. Some who found gold sought San Rafael as an investment for their wealth.

The tiny village clustered around the disintegrating mission began to grow. Citizens promoted themselves, their businesses, and the town to bring growth and prosperity. In 1850, when California became a state, Marin County was one of the original counties carved out of the vast territory. Gen. Mariano Vallejo named many of the counties, and he designated Marin after the sometime outlaw known as Chief Marin. The 1850 U.S. Census shows only 324 individuals living in all of Marin County.

A great portion of the population was made up of former owners of the land grants. The Spanish-speaking owners of the land grants found they were being shoved aside, their land gobbled up by the newcomers. And the Coast Miwok moved further away as the vast land grants were divided into farms and city blocks. Progress was the word of the day, and changes were ahead for the little town of San Rafael. Everyone was an entrepreneur and had a scheme to develop the sleeping village into a giant. As the *Marin Journal* put it, "Every man in the place is of the opinion that he is the person who has caused San Rafael to attain its present prosperity."

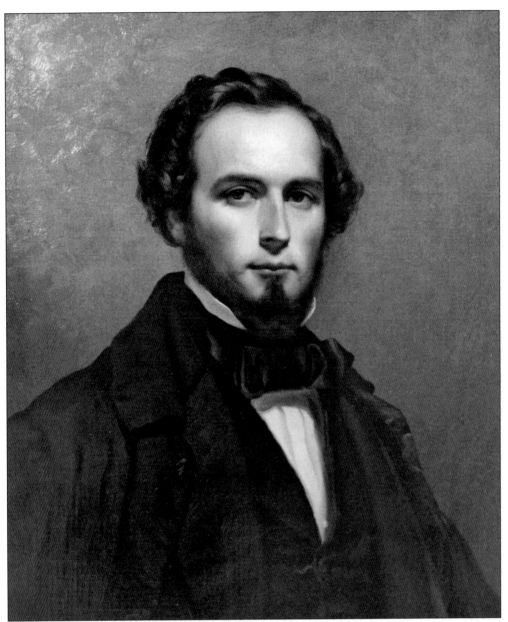

William Tell Coleman was born in 1824 in Kentucky and came to California at the time of the Gold Rush. He was a merchant in several gold-mining towns before relocating to San Francisco. Seeking justice in a lawless town, he founded the Committee of Vigilance in 1851 to restore order to San Francisco. In 1856, he headed the second Vigilante Committee, which was founded to bring two murderers to justice. Coleman came to San Rafael in 1871 and became the dominant figure in the development of the city. He was influential in building the Marin County Courthouse, developing the water system, promoting the railroad, and sponsoring the building of the Hotel Rafael. In 1887, Coleman's finances were mostly tied up in the borax mines of Southern California. When the U.S. government lifted the tariffs on borax, he lost his fortune. He sold his home in San Rafael and his other investments to pay off his outstanding debts. He died in 1893 free of debt.

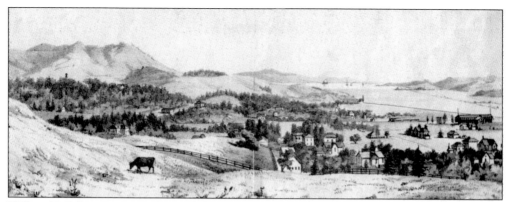

William T. Coleman came to San Rafael in 1871 and immediately saw the potential for development. He purchased 1,100 acres in what he called Magnolia Valley. He planted a nursery of 12 acres to grow shade trees. He hired Hall Hammond of Golden Gate Park fame to help lay out the lots, which became today's Dominican area of San Rafael.

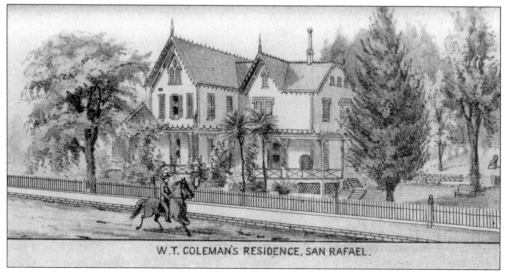

W.T. COLEMAN'S RESIDENCE, SAN RAFAEL.

William Coleman sought a country estate for his wife, Carrie, who was suffering from bronchitis. Discovering the healthy climate in San Rafael, he purchased the house at 1130 Mission Avenue. The house was built as early as 1849 and is the oldest standing house in San Rafael. Coleman did extensive remodeling and improved the grounds to make the dwelling into a showcase.

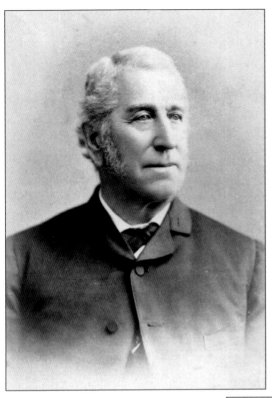

James Miller was born in Wexford County, Ireland, in 1812. He immigrated to Canada in 1828 and then migrated to Missouri with his wife, Mary. He came to California in a wagon train with Mary's father, Martin Murphy, and his family. Mary gave birth to their fifth child en route to California. The Miller-Murphy party arrived at Sutter's Fort on December 15, 1844, and the Millers came to San Rafael in 1845. Miller bought a ranch of 680 acres from Timothy Murphy, with whom he became great friends because they both came from Wexford County, Ireland. The deed is the first recorded in Marin County. Miller made his fortune selling beef to the gold miners in 1849.

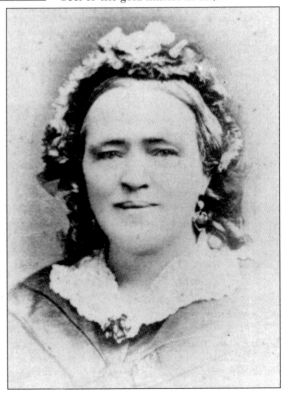

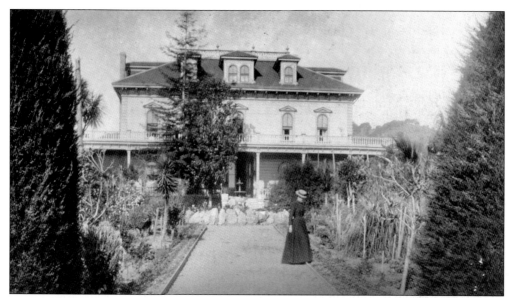

James Miller built the mansion he called Miller Hall on his property north of San Rafael in what is now Marinwood. It was constructed on a knoll in the style of an English manor house. Here Miller and his wife, Mary, raised three sons and seven daughters while conducting a prosperous ranch.

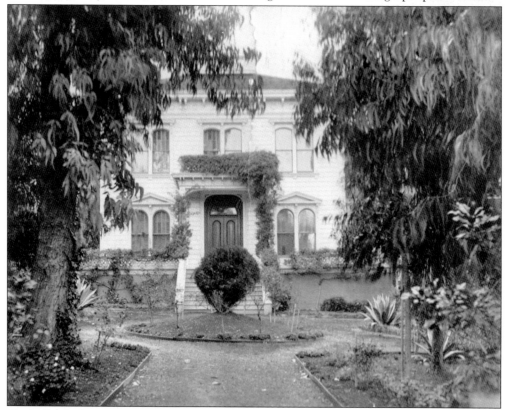

The Millers had a townhouse at Fifth Avenue and B Street where they resided during the winter months. The road north to Miller Hall would often become impassable after the rainy season started.

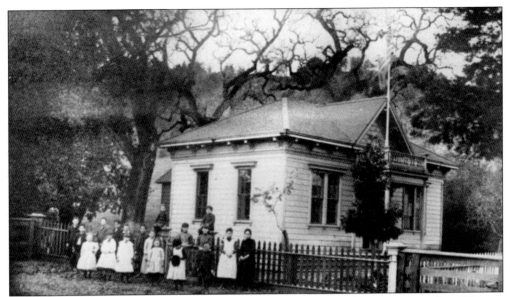

James Miller gave the land for the Dixie School that was erected in 1864. Logs from Nicasio mills were hauled to the site to build the school. The little schoolhouse still stands as a historic landmark but has been moved to Las Gallinas Avenue in Marinwood. The Dixie School District received its name as a dare. During the Civil War era, some Southern sympathizers challenged Miller to name it Dixie. And even though most of Marin was pro-Union, the name stood.

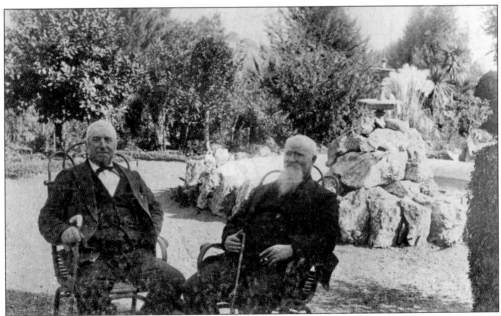

James Miller (left) and John Lucas reminisce about the pioneer days in San Rafael. They had much to talk about, both having seen the beginning of San Rafael and its development.

Dr. Alfred W. Taliaferro was a physician who came to California as part of the Virginia Company. The company, organized in Richmond, Virginia, sailed to California in hopes of making a fortune in the Gold Rush. The men hired the ship *Glenmore* and arrived in San Francisco in October 1849. Many of Taliaferro's shipmates were eager to get to the mines, but he decided to go into agriculture and, with some of the men, rented part of the San Rafael mission lands. He fit into the little village, starting the first drugstore and practicing medicine. He was never interested in collecting money but asked his patients for whatever they could afford. Taliaferro was named the first doctor at San Quentin Prison. He was elected to the California State Assembly in 1853 and 1854, and also served in the state senate. The beloved doctor was mourned by all when he died in 1885. He was buried in the Mount Tamalpais Cemetery.

Jacob, left, and John Orey Baptiste (J.O.B.) Short, below, came across the country with a wagon train that started from Missouri. There were 120 men and 62 wagons. With Jacob and J.O.B. were their mother, Jane Merriner, and two half-sisters, Elizabeth and Catherine Merriner. They headed for Sonoma and then moved on to Novato before finally settling in San Rafael in 1847. The family occupied one of the old mission adobe buildings, which they repaired and expanded. The brothers leased a tract of land in Nicasio in 1853 from Timothy Murphy and kept a large herd of cattle. They fattened their stock and sold them to the hungry gold miners. With the profits, they bought much of the south side of San Rafael, which they called Short's Addition. The Short School was built there, honoring the pioneer family.

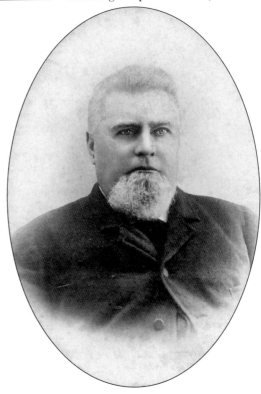

Adam Murray was born at sea on a ship from Scotland carrying his father and mother to Canada. He married Euphemia Paul in Ontario, where he pursued his occupation as a carpenter. Hearing of opportunities in California, he found his way to Marin County. Murray became a contractor and built many homes, including the Gate House at Boyd Park, which is now the home of the Marin History Museum.

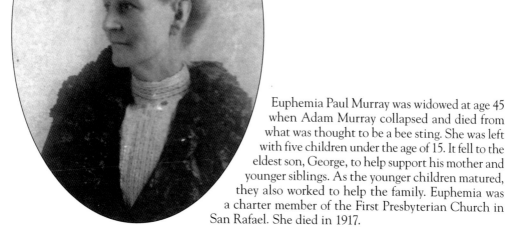

Euphemia Paul Murray was widowed at age 45 when Adam Murray collapsed and died from what was thought to be a bee sting. She was left with five children under the age of 15. It fell to the eldest son, George, to help support his mother and younger siblings. As the younger children matured, they also worked to help the family. Euphemia was a charter member of the First Presbyterian Church in San Rafael. She died in 1917.

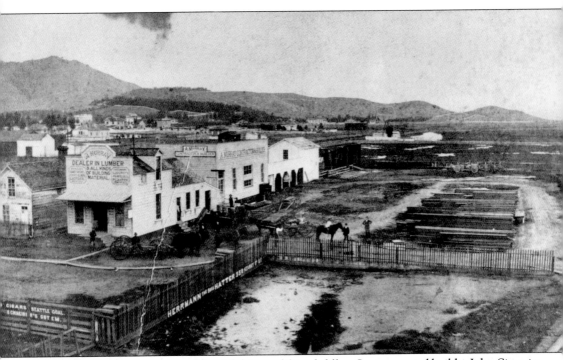

Adam Murray was in partnership with his good friend, fellow Scotsman and builder John Sims, in a lumberyard on Second Street. When Sims died in 1879, Murray bought out Sims's share, took over the business, and changed the name to the A. Murray Lumber Company. This is a view of the yard looking east from approximately Second and A Streets.

Five

FROM HERE TO THERE

In the early days, the San Rafael Creek extended as far as First and C Streets, where schooners or barges ran to San Francisco hauling freight. Passengers heading for San Francisco traveled a difficult and time-consuming route via stage to Point San Quentin, where schooners or a steamer carried them across the bay. In 1869, the transcontinental railroad was completed, and the age of the railroad came to San Rafael. Stockholders raised $50,000 to establish the San Rafael and San Quentin Railroad; regular train service to Point San Quentin started in March 1870. The North Pacific Coast Railroad (NPC) was incorporated in 1871. Backed by men with lumber interests in west Marin and the Russian River area, the NPC ran a narrow-gauge line from Sausalito through the Ross Valley, out to Point Reyes, and then north along Tomales Bay to the timber country in Sonoma. San Rafael was off the main line, with only a spur track from San Anselmo connecting to the station at B Street. The citizens of San Rafael were outraged. Peter Donahue came to the town's rescue.

In 1878, Donahue, a Scottish immigrant who founded the Union Iron Works in San Francisco, extended his broad-gauge San Francisco and North Pacific Railroad (SF&NP) from Petaluma into San Rafael. The line was extended to Tiburon, and a new depot was constructed in San Rafael on Tamalpais Avenue between Third and Fourth Streets in 1884. Both the NPC and the SF&NP railroads operated ferries and were in fierce competition for providing the fastest service to their passengers. Fast and reliable electric train service, pioneered by the North Shore Railroad, successor to the NPC, began in 1903. It carried San Rafael residents to work, school, and to scenic Marin spots until 1941. These early railroads were part of a merger that formed the Northwestern Pacific Railroad (NWP) in 1907. In 1903, automobiles were banned from many county roads, were prohibited from night driving, and were limited to a 15-mile-per-hour speed limit. Ultimately, the automobile was fully accepted. The dusty streets of downtown were paved, and the horse-drawn carriages vanished. The opening of the Golden Gate Bridge in 1937 brought the demise of commuter rail service when Marin residents took to their automobiles.

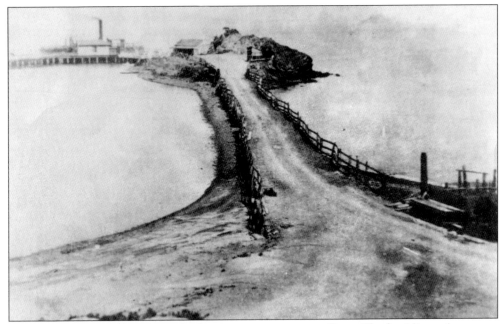

Getting to San Rafael in the early days was no easy matter. Capt. Charles Mintern's steamer *Petaluma* stopped at Point San Quentin on its San Francisco–to–Petaluma run as early as 1855, and by the early 1860s, Bill Barnard's Stage Company was running between "downtown" San Rafael and Point San Quentin. In 1865, a toll road was completed, reducing travel time to San Francisco by one hour. In this 1860s photograph of Point San Quentin, a ferry steamer sits at the dock.

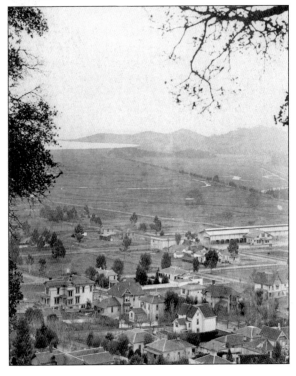

The Union Station is at center right in this c. 1900 photograph. The line of trees heading to Point San Quentin marks the location of the 1865 San Quentin toll road, today's Francisco Boulevard East. The salt marshes, broken by meandering sloughs and inlets, are evident south and east of Third Street.

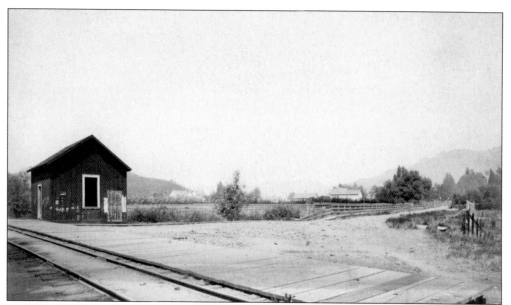

The NPC Railroad completed its single narrow-gauge track from Junction, as San Anselmo was called then, to San Rafael in 1874. In this 1877 photograph of the West End Station, the vineyard of Zopf's Family Resort and Wine Garden can be seen on the hill behind the station. The road on the right is G Street.

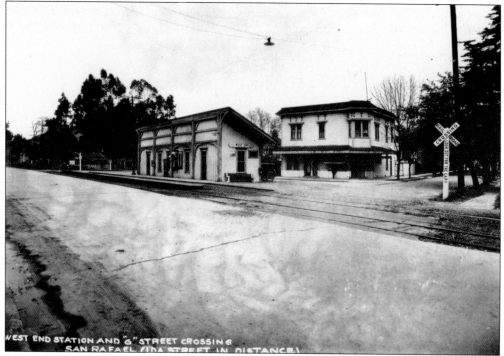

WEST END STATION AND "G" STREET CROSSING
SAN RAFAEL (IDA STREET IN DISTANCE)

The West End Station was enlarged when riders demanded a covered station, but when the railroad track was double-tracked, the portion of the station covering the track was removed, leaving West End Station looking like this. In the late 1920s, a Mission Revival–style station replaced this wooden structure. The building to the right of the station on the corner of G Street still exists.

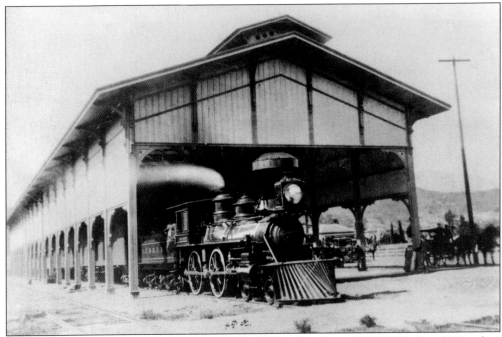

This San Rafael railroad station was built by Peter Donahue for his SF&NP Railroad. Donahue completed his line from Petaluma to Tiburon in 1884. The immense, 50-foot-by-300-foot building was completed on May 1, 1884, on Tamalpais Avenue between Third and Fourth Streets. In this 1890s photograph, a train with its steam locomotive has stopped at the station.

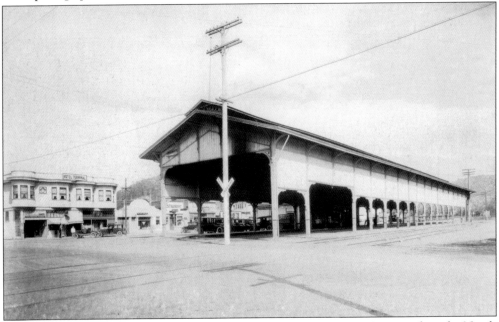

Donahue's SF&NP Railroad station in San Rafael became the Union Station when the North Shore Railroad started sharing it in 1906. The station was always noisy and drafty. It was replaced in 1929 by the Northwestern Pacific Railroad with a Mission Revival–style station. It is home to the community service organization Whistlestop today.

It is a wet day at the B Street Station in 1896. The man on the right is standing on the station platform. The horse-drawn carriages wait for passengers. The Flatiron Building at Second and B Streets is the building in the background on the far right. It was built in 1883 originally as a saloon and rooming house catering to railroad workers.

This is a railroad crossing along Second Street, c. 1915. The tracks ran on Second Street west from the B Street Station. The electric third rail can be seen on the right of the tracks along the fence. The train would lose electric power at each crossing, coast through the crossing, and pick up power on the other side.

41

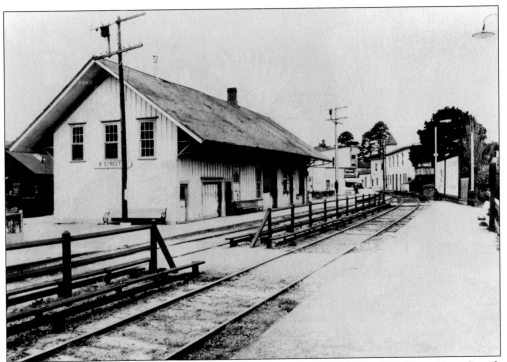

This is the B Street Station in 1927. Directly beyond the station is the small B Street News Stand; the Flatiron Building is to the right of the tracks in the background. The tracks are double-tracked and electrified. The station was replaced with one in the Mission Revival style.

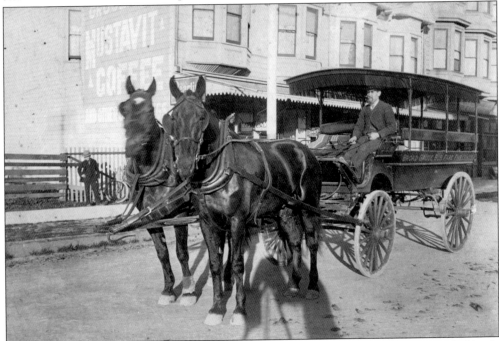

The narrow-gauge B Street Station and the broad-gauge station of the SF&NP were a half-mile apart. This is the broad-gauge bus that ran between the two stations. The fare was 5¢.

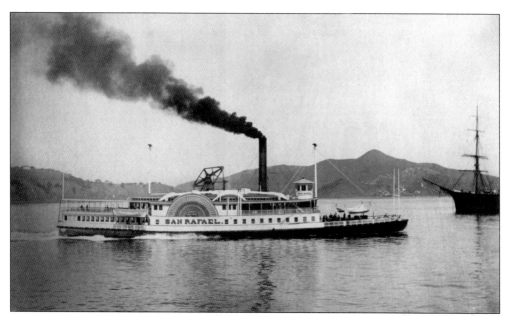

The NPC Railroad's ferryboat *San Rafael* ran between Sausalito and San Francisco from 1877 until a foggy night in 1901. The ferryboat *Sausalito* collided with her off Alcatraz, and she sank with the loss of three lives.

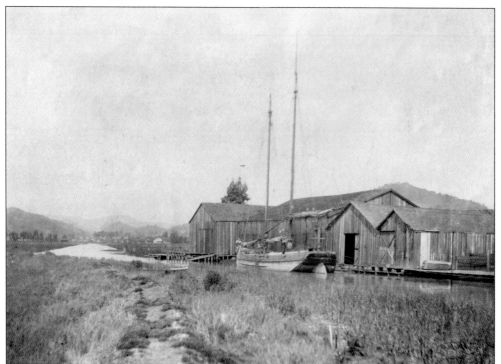

Hay scows came up the San Rafael Creek channel. These flat-bottom boats carried a sail for crossing the bay. In this early 1900s photograph, a scow is docked at one of several hay-storage barns along the canal. The creek channel was dredged and straightened in 1908, and a turning basin was constructed at Irwin Street.

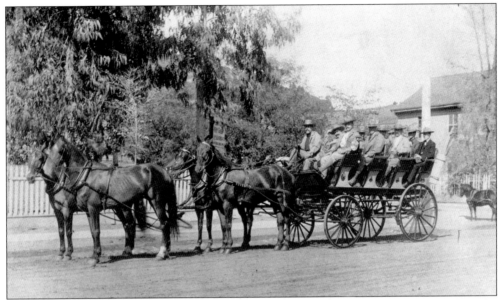

Tally-hos were the most elegant means of transportation before the automobile appeared on the streets of San Rafael. Livery owner Neil McPhail drives businessmen S. K. Herzog, Louis Hughes, Arthur Scott, Elwood Rake, Dun Troy, Richard Kinsella, M. F. Cochrane, Tommy Day, Eugene Connell, and an unidentified person in this 1890s photograph.

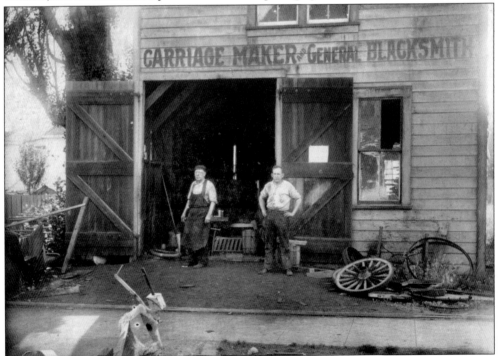

William O. Smith learned the smithery trade on his native Prince Edward Island and opened a blacksmith shop on A Street between Second and Third Streets around 1895. Smith is shown here, on the left, with his son William F. in front of the smithy in the early 1920s. The younger Smith would later recall how hard the work of a village blacksmith was.

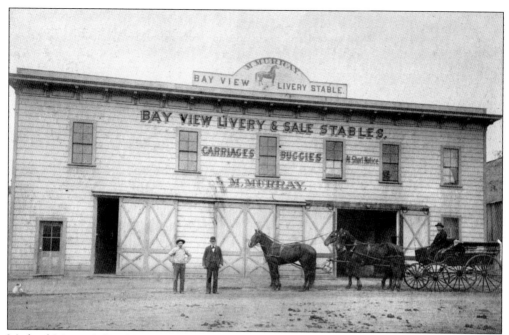

Michael Murray's Bay View Livery Stable was a fixture on the west side of C Street at Third Street for more than 30 years. Murray, a native of Ireland, arrived in San Rafael in 1870. The livery was destroyed by fire in 1880; the horses were saved, but the hay burned for four days and nights. The livery was rebuilt and did a lively business in the years when the Hotel Rafael was a popular resort destination.

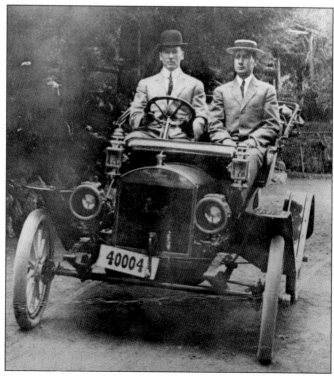

Dr. Harry O. Hund of San Rafael was an early adopter of the automobile. Here he sits behind the wheel of his 1908 Maxwell with his brother Frederick. Harry made house calls to his patients using an automobile.

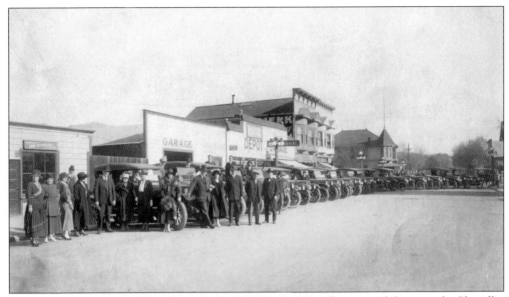

In 1915, Joseph Codoni and Frank Riede, local dealers for Chandler automobiles, staged a Chandler cavalcade promotion in San Rafael on Fourth Street. The National Hotel is in the background on the corner at Tamalpais Avenue.

The opening of the Golden Gate Bridge in 1937 sealed the railroad's fate. The American obsession with the automobile had begun in earnest, with train ridership falling to half its 1930 volume. Despite protests by train lovers, commuter service ended on February 28, 1941.

Six

CIVIC PRIDE

Marin County was one of the original 27 counties formed by the first California Constitutional Legislature, which met in Monterey in 1849. After California formally became a state in 1850, the new legislature named San Rafael the county seat in 1851. The first meeting of the Court of Sessions was held in the old mission. The name of this governing body was later changed to the Marin County Board of Supervisors. Early pioneers established the positions of judge, sheriff, board of supervisors, county clerk, and treasurer to run the county business. The Baltimore and Frederick Mining and Trading Company, a gold-seeking group from Maryland, supplied the first judges, Dr. James A. Shorb and Ai Barney, and the first sheriff, Samuel S. Baechtel. The sheriff's first job was to erect the jail.

In 1853, the county moved out of the dilapidated mission and rented Timothy Murphy's old adobe home from Timothy Mahon. In 1858, the building was purchased for $5,000 to use as the Marin County Courthouse. Civic pride spurred the citizens to replace the old adobe building— sometimes called "the mud heap"—with a more prestigious building. The new Marin County Courthouse was designed in the style of classical Greek architecture. The design projected a grand and prosperous presence, which the citizens found more appropriate to their hopes and dreams. The courthouse served as the location of Marin government for almost 100 years.

After the courthouse was built, San Rafael began a growth spurt. The railroad came to town, and ranch land was divided into lots for homes. An expectation of growth spurred the town to incorporate in 1874. The new city's leaders were Sidney V. Smith, Joseph B. Rice Sr., Dr. Alfred Taliaferro, William J. Miller, and Jacob Short. Their first order of business was to rent rooms in Short's Hall for town meetings. Soon afterward, San Rafael's citizens became aware of their need for a fire department, a policeman, a library, and a hospital, and they rallied to bring these necessary improvements into being.

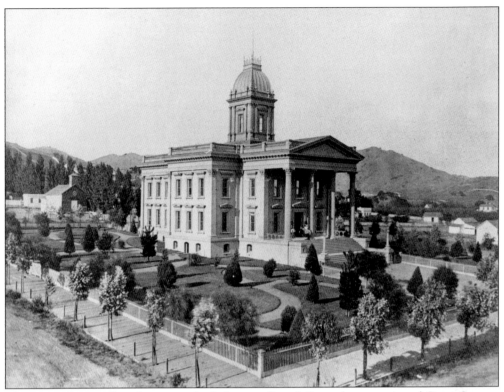

The Marin County Courthouse was built fronting Fourth Street between A and Court Streets. The cornerstone for the building was laid on August 2, 1872, with an elaborate ceremony. The building, designed by the firm of Kenitzer and Raun, was constructed at a cost of $51,000. All county business took place here for nearly 100 years. Until 1893, hangings were held in the basement of the courthouse. After this date, hangings were held at San Quentin Prison. The building was destroyed by fire in 1971.

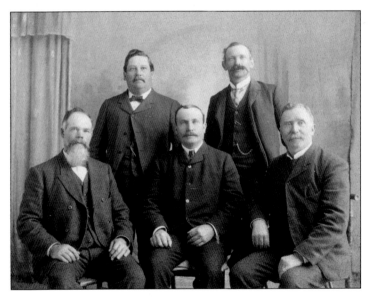

The Marin County Board of Supervisors in 1904 had representatives from the five districts it oversaw. Pictured here from left to right are (first row) Henry Goudy representing Tomales, Robert W. Johnson representing San Rafael, and Charles J. Dowd representing Mill Valley; (second row) Gus Pacheco representing Novato and Frank J. Murray representing San Rafael.

San Rafael's first city council met at a saloon in Short's Hall on the southeast corner of Fourth and C Streets. After the incorporation of San Rafael on February 18, 1874, the first officials were elected, and appointments were made for city clerk and treasurer. There was also the need to raise funds for town improvements. The new town was optimistic about the future.

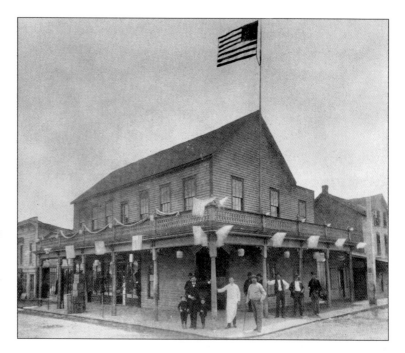

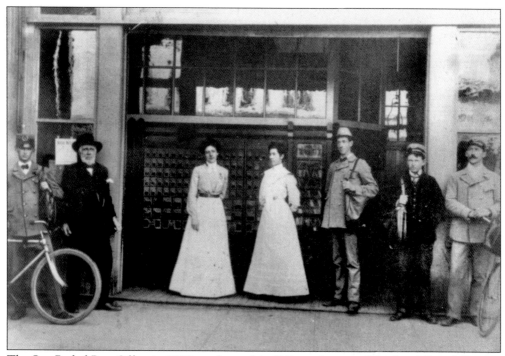

The San Rafael Post Office in 1900 was located on B Street between Third and Fourth Streets. Pictured from left to right are Frederick O'Toole, postmaster William N. Anderson, Nettie Ryan, Agnes Watson, Jim Redmond, Victor Becker, and an unidentified man. The San Rafael Post Office had just inaugurated home postal delivery, and O'Toole, Redmond, and Becker were the new mailmen who delivered the mail.

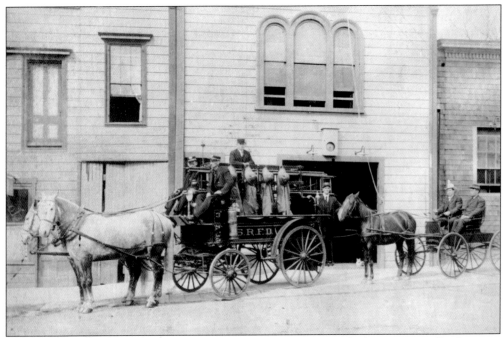

The San Rafael Fire Department was organized in December 1874. The firemen were all volunteers, who originally called themselves the San Rafael Hose Company. The first fire station was located on C Street between Fourth Street and Fifth Avenue. Capt. William Kane is seated in front of the hook-and-ladder wagon.

In the early days, the volunteer firemen would run to a fire pulling the hose cart by hand behind them. Fire protection was improved when two trained fire horses were purchased, named Tom and Jerry, that were beloved by all the young boys in town. Tom and Jerry were retired in 1913 when a motorized wagon was acquired.

Peter O'Brien was the second elected police chief of San Rafael, succeeding John Healy. O'Brien started working for the police department in 1894 as a night watchman. He became the chief of police in 1919 and served until his death in 1933 at the age of 78. (Courtesy San Rafael Police Department.)

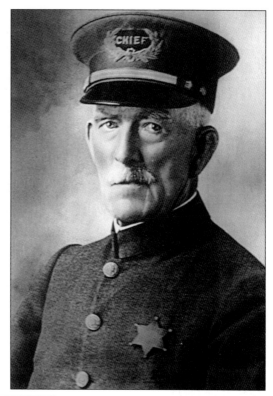

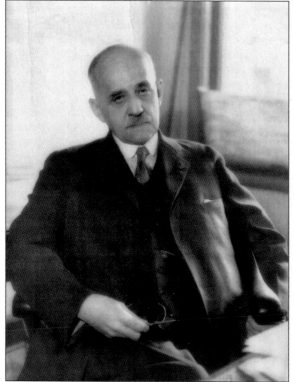

Frank Marion Angelotti was born in San Rafael in 1861. He became the Marin district attorney at age 23. He was elected a superior court judge and served in that position until becoming an associate justice of the California Supreme Court. He became chief justice in 1914. He was born of Italian immigrant parents and rose to the pinnacle of his profession through the application of his education and hard work.

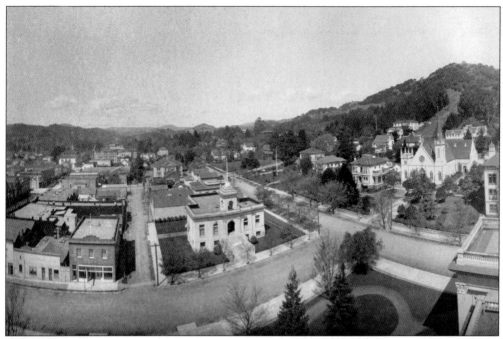

A new San Rafael City Hall was built in 1909 on A Street. Before this building was constructed, city officials met and did business in various rented spaces. The basement housed the police office and garage, along with one jail cell. The mayor's office and an assembly hall were upstairs.

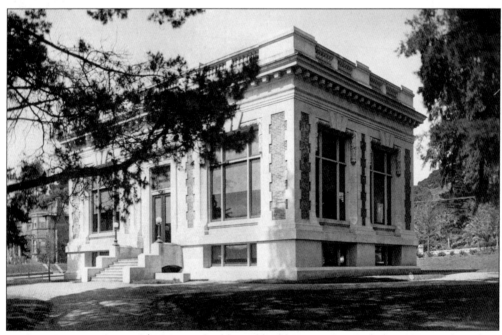

Andrew Carnegie donated $25,000 to build a public library in San Rafael in 1904. Before plans could be executed, the San Francisco earthquake of 1906 intervened, and all construction was delayed as San Francisco was rebuilt. Designed by the Reid Brothers and built by the Hoyt Brothers, the library was finally finished and was dedicated on January 9, 1909.

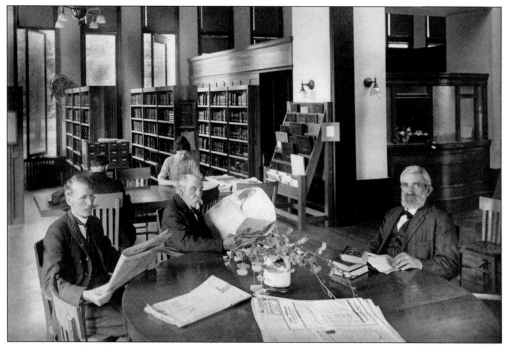

The San Rafael Public Library provided a quiet and congenial place for the citizens to read the newspaper or learn something new. The library was far away from the bustle of Fourth Street.

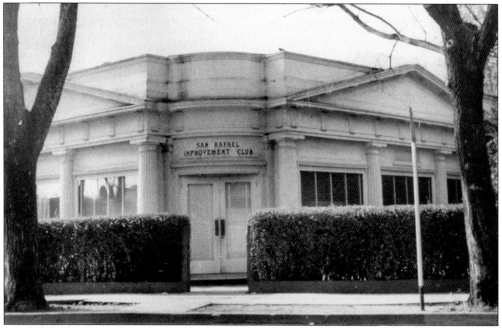

The San Rafael Improvement Club began in 1902, with its main purpose to eradicate the deadly mosquito. Later the club was responsible for planting shade trees and other civic projects. The building was the exhibition pavilion of the Victor Talking Machine Company at the 1915 Panama Pacific International Exposition in San Francisco. The structure was floated across the bay and erected at the corner of Fifth and H Streets in 1916.

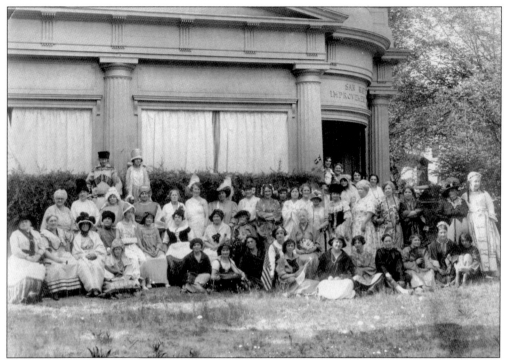

The ladies of the San Rafael Improvement Club pose outside their building after attending the "All Nations" program celebrating the origins of the many immigrants who came to San Rafael.

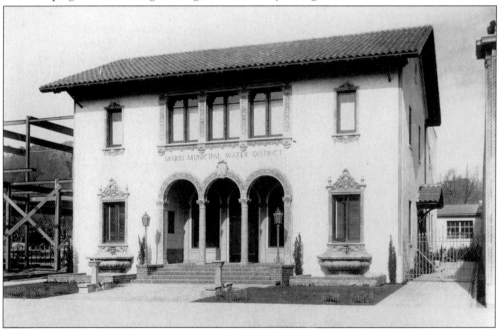

The administration building of the Marin Municipal Water District (MMWD) was constructed in 1924 at 425 Fourth Street. The MMWD was created by voters in an election held on April 13, 1912. In 1915, a ballot measure passed to issue $3 million in bonds to buy the Mount Tamalpais watershed and build Alpine Dam.

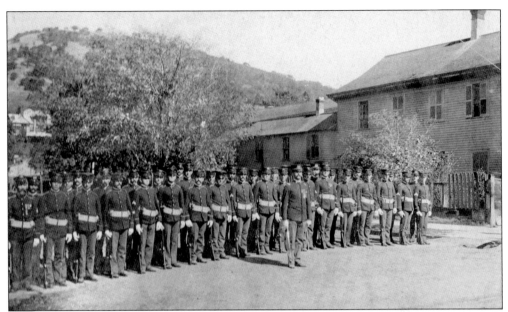

Company D, 5th Infantry, of the California National Guard was organized in 1885. One of the reasons for organizing the company was to have a force prepared to handle any outbreak at San Quentin Prison, which was a real threat to San Rafael citizens in those years. Company D was called up for duty in the Spanish-American War and again in 1906 when an earthquake struck San Francisco.

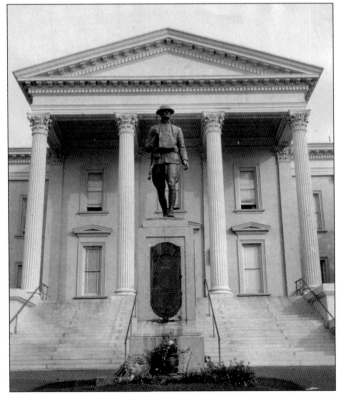

The "Doughboy" statue was designed by Joseph J. Mora as a memorial for Marin County soldiers who died in World War I. In 1922, thousands attended the unveiling of the statue that stood in front of the courthouse. The statue was moved to the Marin Civic Center in 1971 and stands on the Avenue of Flags in front of the Veterans Memorial Theater.

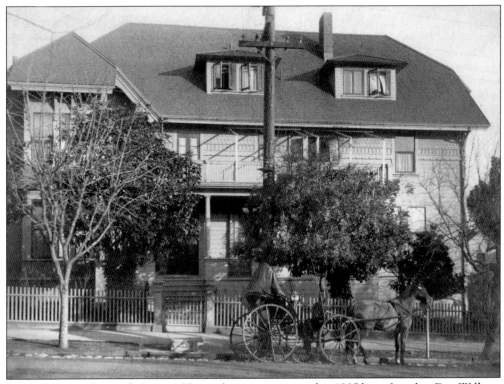

San Rafael's first hospital, Cottage Hospital, was incorporated in 1905 by cofounders Drs. William Farrington Jones, Henry O. Howitt, and William J. Wickman. The hospital was first located at Fifth and Lincoln Avenues. Its 14 beds were overwhelmed by refugees of the 1906 earthquake and fire. In March 1907, the doctors purchased this two-story home on Nye Street at Mission Avenue, remodeled it, and relocated the hospital.

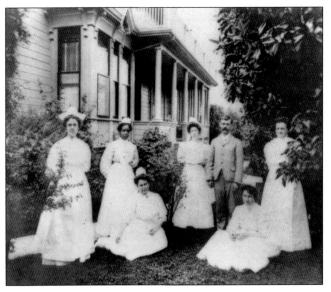

Shortly after the Cottage Hospital moved to Nye Street in 1907, a school of nursing was started. The students attended lectures conducted by the doctors five evenings a week and worked day and night shifts while learning the practical aspects of nursing. The school was forced to close in 1912 when state regulations changed. The Cottage Hospital nursing staff, c. 1910, are, from left to right, (seated) Laura Adams and Emma Gilmore; (standing) unidentified, Edna Brown, ? Johnson, ? Eaton, and ? Hogan.

Louisiana (Mrs. A. W.) Foster donated an ambulance to Cottage Hospital in 1905. It was at first pulled by two black mares and then was motorized with a Studebaker engine mounted on its chassis. In 1920, the founding doctors sold Cottage Hospital to Mrs. Elsie M. Simmons, later Mrs. Joseph Dias. The ambulance was eventually sold for use as a hearse, and a Pierce-Arrow ambulance was acquired. Joseph and Elsie Dias pose with the ambulance.

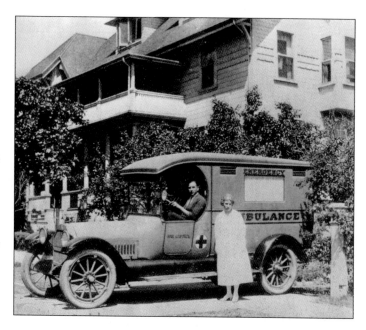

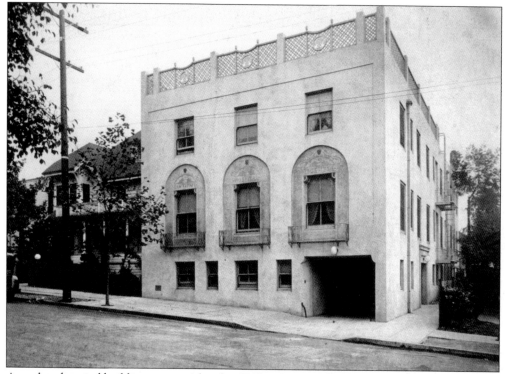

A modern hospital building was completed in 1927 on Nye Street adjacent to the existing Cottage Hospital. The fireproof concrete building had large sunrooms, a modern operating room, and a kitchen. There were 45 beds in wards and private rooms. Fees ran from $3 to $4 per day in the wards and up to $8 per day for a private room.

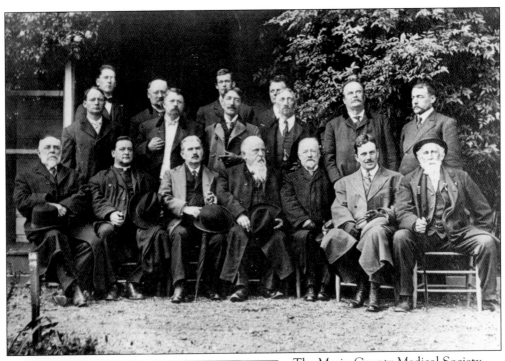

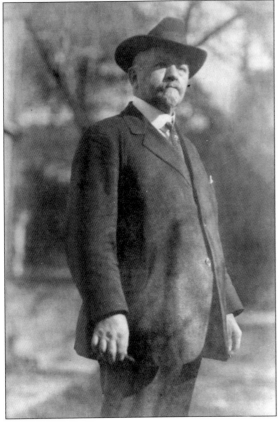

The Marin County Medical Society was founded in 1898 by Dr. William Farrington Jones. In this 1907 photograph taken at a dinner meeting at Pastori's in Fairfax, the members are, from left to right, (first row) Dr. John Keck, Rev. Joseph Byrne, Dr. A. G. Winn, Dr. S. M. Augustine, Dr. George Powers, Dr. Ernest Chipman, and Dr. H. J. Crumpton; (second row) Dr. H. W. Dudley, Dr. William Farrington Jones, Dr. H. O. Howitt, Dr. J. H. Kuser, Dr. William J. Wickman, and Dr. Arthur H. Mays; (third row) Dr. Harry O. Hund, Dr. F. J. Hund, Dr. S. M. Alexander, and Dr. F. E. Sawyer.

Dr. William Farrington Jones was born in Eureka, California, in 1860. He graduated from Cooper Medical College in San Francisco in 1887. In San Rafael, Dr. Jones conducted a private practice, operated Cottage Hospital with his cofounders, served as the county and city health officer, and was the surgeon for the Northwestern Pacific Railroad. He founded the Marin County Medical Society in 1898. The kindly physician died in 1929.

Seven

GETTING DOWN TO BUSINESS

Today it is hard to believe that San Rafael was once a cow town, but cattle was actually the first business of the town. Longhorn steers were driven by vaqueros off the hillsides and down Fourth Street on their way to market. A number of early pioneers made their fortunes supplying beef to San Francisco and to prospectors in the gold country. A slaughterhouse was built along San Rafael Creek from which beef was shipped across the bay.

John A. Davis and Daniel T. Taylor, members of the Baltimore and Frederick Trading and Mining Company, are credited with opening the first store in San Rafael. They sold general merchandise. A meat market followed in a short time. Other early pioneer businessmen, the lumbermen and sawyers, took advantage of the redwood trees in the neighboring hills and valleys, and established lumberyards and mills. Carpenters were in great demand. Many were to make a prosperous living tending to the care of carriages and horses before the days of the automobile. By 1866, the *Marin Journal* boasted that the town had three stores, two hotels, two boarding houses, one restaurant, two livery stables, three boot makers, two blacksmith shops, a butcher shop, a clock maker, a barber, three lawyers, and a physician.

The completion of the railroad brought weekend and summer crowds, and numerous hotels opened. San Rafael was a lively place with a saloon on almost every corner. Specialty shops—millineries, candy stores, plumbing shops, laundries, nurseries, and hardware stores—came with the increased growth in the town. Bankers and real estate agents established themselves in the downtown area. The Chinese clustered along the east side of C Street below Fourth Street with shops, laundries, and gambling establishments. Fourth Street, even before the street was paved, became the premier shopping area for all of Marin. Jacob Albert's small dry-goods business, which opened in 1895, became the largest department store in Marin. National chain stores, such as Woolworth's, also located on San Rafael's Fourth Street.

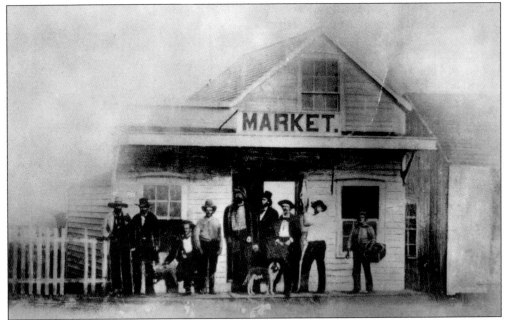

One of San Rafael's first stores, a meat market, opened in 1858 on the east side of C Street between Third and Fourth Streets. Among those pictured in front of the market in this 1860s photograph are Ned Eden, Elisha DuBois, Jerome Barney, Dan Taylor, and Val Doub. Stores such as this were popular gathering spots to catch up on the latest events and gossip.

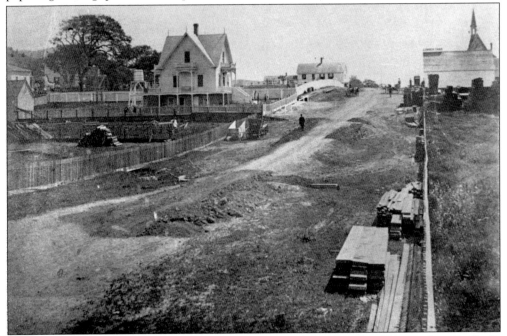

This is Fourth Street looking east from about F Street in the early 1870s. The steeple of St. Paul's Episcopal Church at Fourth and E Streets is in the right background. Directly in front of the church is the Shaver Lumber Yard. Shaver later had a large lumberyard and planning mill at Shaver and First Streets.

Ai Barney and his son Jerome founded Marin's first newspaper, the *Marin County Journal*, in 1861. Jerome had learned to set type as a boy. The newspaper had a strong pro-Union stance during the years of the Civil War. The newspaper was sold to Simon Fitch Barstow in 1872, and by the time of this 1883 photograph of the building at Fourth and D Streets, the name of the newspaper had been changed to the *Marin Journal*.

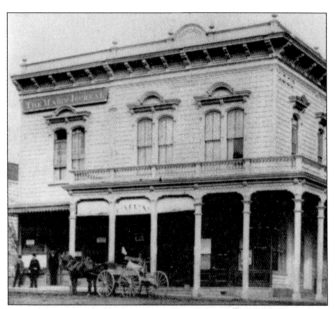

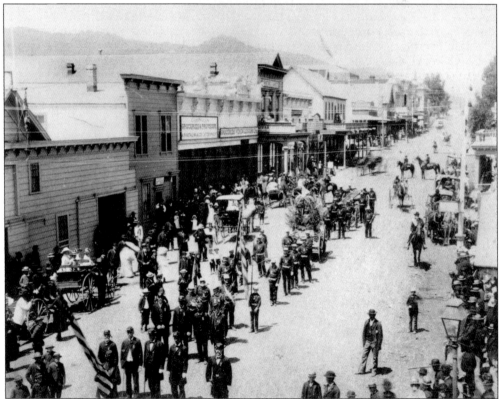

A parade marches down Fourth Street between B and C Streets on July 4, 1885. The third building on the left is Camille Grosjean's store, which sold groceries, wines, and liquors. Grosjean was born in France, immigrated to Louisiana, and came to San Rafael in 1872. His personal chef, Marcel, cooked such excellent Creole food that the store became a popular place to have lunch in downtown San Rafael. The building still stands at 1225 Fourth Street.

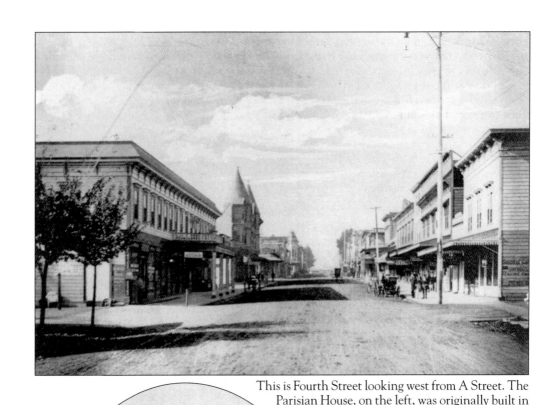

This is Fourth Street looking west from A Street. The Parisian House, on the left, was originally built in 1872. The hotel, operated by Etienne Sivieron, served excellent food and fine liquor. A Brush arc light hangs from the pole on the right; San Rafael's first electric lighting came in the late 1880s.

The Pratt Building, located on the northeast corner of Fourth and B Streets, was built in the early 1870s by Frederick H. Pratt. Pratt was San Rafael's postmaster from 1876 to 1882. The upper floor of the building was occupied by the Pratt family, while the lower floor housed a general merchandise store. In this 1880s photograph, Pratt stands with his arm on the post in front of the store and post office, and his wife and several children are on the upper porch.

The Centennial Building was constructed in 1876 on the northwest corner of Fourth and C Streets where Timothy Murphy's adobe house had been. Oliver Irwin, a prominent businessman, constructed the three-story brick building. Thomson's Dry Goods was a ground-floor tenant, and Dr. William Farrington Jones had his office upstairs for many years. The building was demolished in 1928, and the Bank of Italy was constructed.

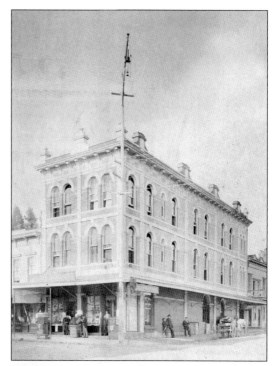

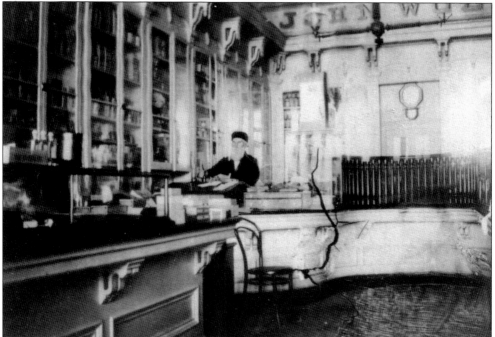

John Carey Wolfe was San Rafael's popular village druggist. He was born in Ireland, one of 12 children. He came to San Rafael in the early 1870s and found the town much to his liking. He opened his drugstore on the north side of Fourth Street between B and C Streets. Wolfe's Liniment was a popular treatment for burns and bruises. Wolfe built a beautiful home on the south end of D Street. Wolfe Grade, the road over San Rafael Ridge, was named for him.

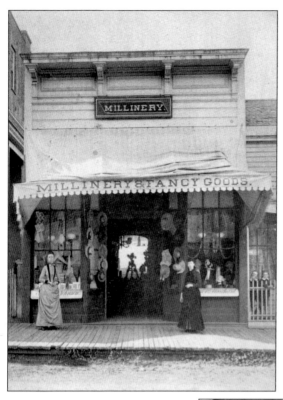

What fine hats the women of San Rafael could buy at the Johnson-Kinsella Millinery and Fancy Goods on Fourth Street. Sisters and proprietors Mary Kinsella (on the left) and Kate Johnson stand in front of the shop around 1887. Their children, Jack Kinsella and Robert Johnson Jr., are behind the fence on the right.

The millinery on Fourth Street is shown here in 1899. Times have changed, and the women's dresses and the window displays have been updated. Milliner Pauline Murray, daughter of Adam and Euphemia Murray, and bookkeeper Georgia Finlayson stand in front of the shop.

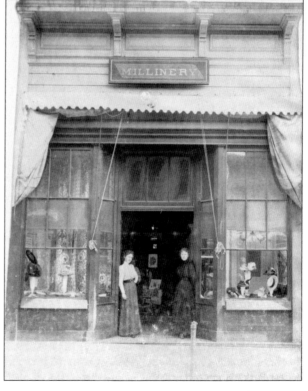

Jacob Albert, a Lithuanian immigrant, came to Marin County in 1890 and peddled dry goods to ranchers in west Marin. In 1895, he opened a store, The Wonder, next to the southeast corner of Fourth and B Streets. The store was moved several times into increasingly larger spaces; it was incorporated under the name Albert's, Inc., with branches later in San Anselmo, Mill Valley, and Richmond.

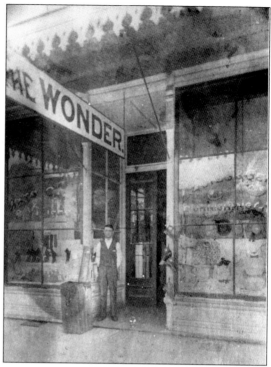

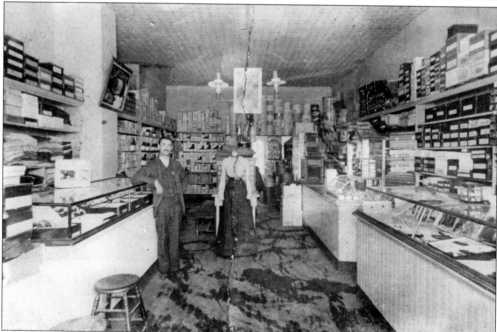

Beginning in this small store with its neatly stacked merchandise, Jacob Albert achieved much. The dry-goods business grew to be the largest department store in Marin and was sold to Macy's in 1952. Albert constructed the Albert Building in 1930 at the corner of Fourth and B Streets, the tallest building at the time and the first with an elevator. He donated the land to the city for Albert Park, which today is the city's main park.

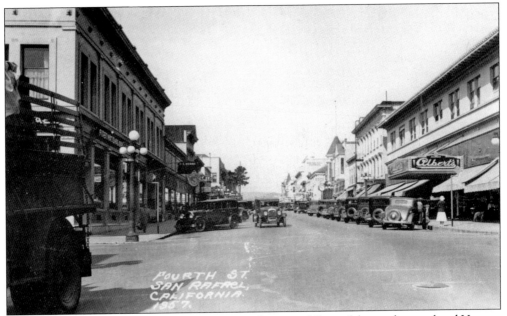

Jacob Albert expanded his department store into the ground floor of the newly completed Herzog-Rake Building in 1915. In this 1934 photograph of Fourth Street looking west from B Street, it is evident from the line of parked automobiles that San Rafael had become a shopping mecca.

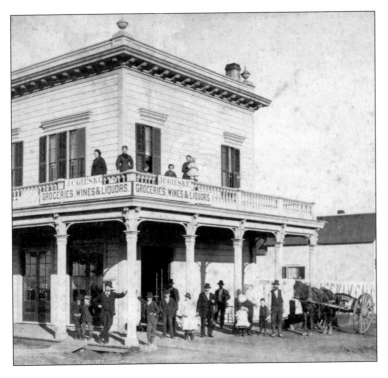

John C. Gieske, a native of Germany, opened a grocery store on the corner of Second and B Streets in 1873. His son Henry joined him in the grocery business and later ran a saloon there. The Gieske family and boarders lived upstairs.

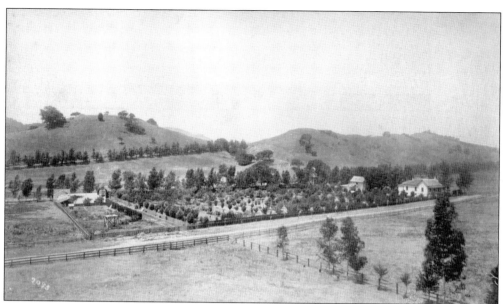

Robert J. Trumbull established a nursery at the west end of town in the 1870s. Advertisements for the Nursery Depot at H and Center Streets promised 200,000 varieties of plants and 100 varieties of roses. The nursery building and entrance, on the left, fronted Center Street at today's J Street.

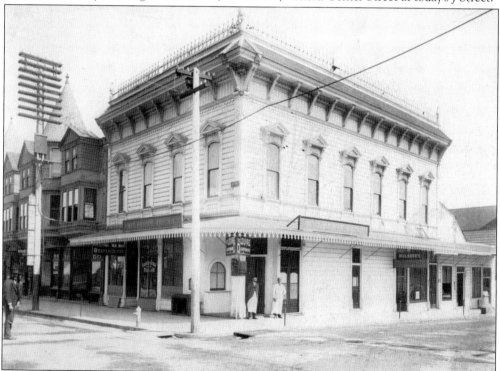

This building, still standing on the southeast corner of Fourth and B Streets, was constructed in 1883 by Patrick McDermott. The upstairs was originally the family's quarters. At the time of this 1898 photograph, the Louvre, serving beer and whiskies, is the corner storefront; a small hotel, known as the Mulberry House, and the Oyster Depot occupy the rest of the building.

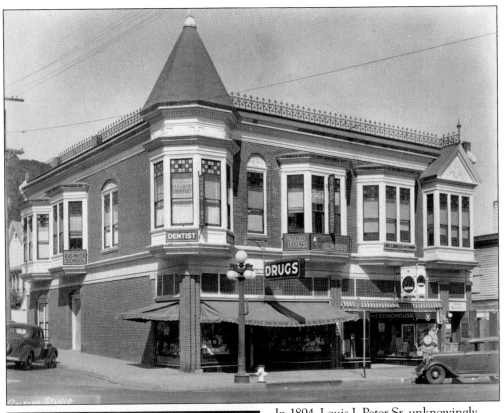

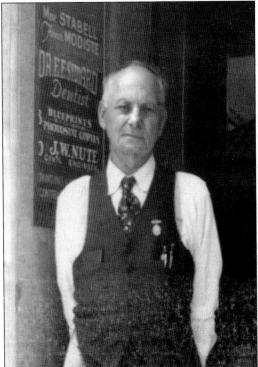

In 1894, Louis J. Peter Sr. unknowingly created one of the most lasting and recognizable business landmarks in San Rafael. Peter moved an existing building on the site on the northeast corner of Fourth and C Streets to make room for the new building. The bricks came from the Fortin Brickyard on Point San Pedro, the predecessor of the McNear Brick and Block Company.

Louis J. Peter came to San Rafael from France in 1876 and settled on C Street, where he established a tailoring shop and raised his family. Louis J. Peter Jr. was born in 1872. When he finished grammar school in San Rafael, there was no public high school for him to attend, so he learned his father's trade of tailoring. He is pictured here in 1936 in front of the family's Fourth Street building.

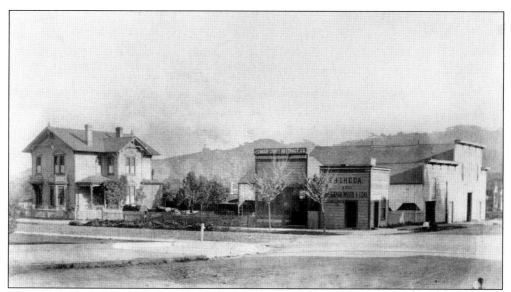

The Cheda family settled in San Rafael in 1878. Family patriarch Gaudenzio Cheda came to California from Switzerland in search of gold. In San Rafael, he bought a feed and fuel business on the southeast corner of Fourth and A Streets. The family home, the coal yard, and a stable are shown in this early 1880s photograph. The home was later moved to 907 Mission Street, where it still stands.

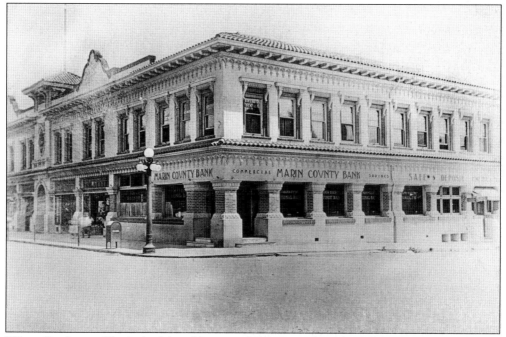

When Gaudenzio Cheda died, his eldest sons Silvio H. and Vigilio J. B. took over the feed and fuel business. In 1899, Silvio Cheda, at the age of 30, established the Marin County Bank. The handsome bank building was constructed at Fourth and A Streets in 1910. The Cheda brothers were active in public affairs for many years.

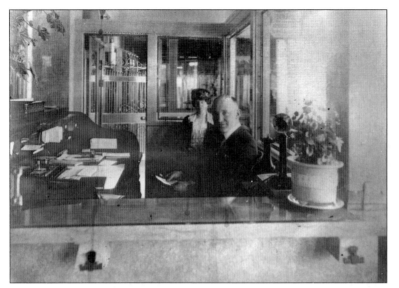

George Cheda, the youngest child of Gaudenzio and Antoinette Cheda, worked in his brother's Marin County Bank as a cashier. He is pictured here in his office with his sister Iridie.

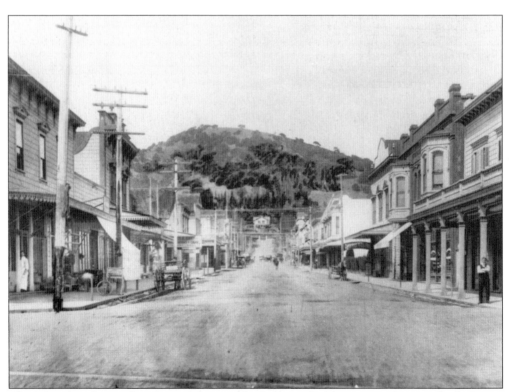

The railroad tracks run along Second Street in the foreground of this *c.* 1900 photograph of B Street. San Rafael Hill rises in the background. Numerous businesses were located on B Street in the blocks below Fourth Street. The gentleman on the right stands in front of Gieske's Grocery.

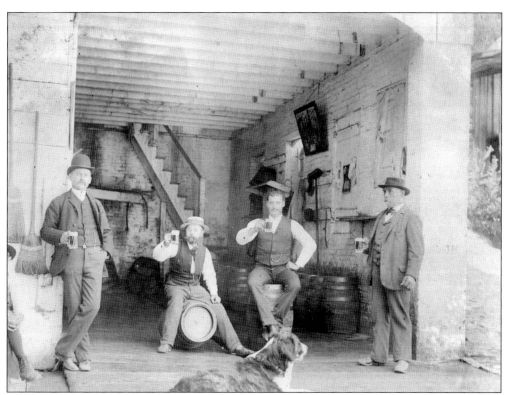

The San Rafael Brewery, located on Greenwood Avenue west of Gerstle Park, made high-quality steam beer. The brewery was established in the 1870s by Bavarian beer master Fritz Goerl (second from left). Goerl's partner for many years was Henry F. Boyen (third from left). This photograph dates from the 1880s. Goerl sold the business in 1905 and died in a tragic accident one year later.

This is a view of the San Rafael Brewery and the Fritz Goerl home at 119 Greenwood Avenue. After the brewery closed, the main building was used briefly as a roller-skating rink. In the 1930s, the property was turned into the Auto Camp, a place for visitors to camp with their automobiles.

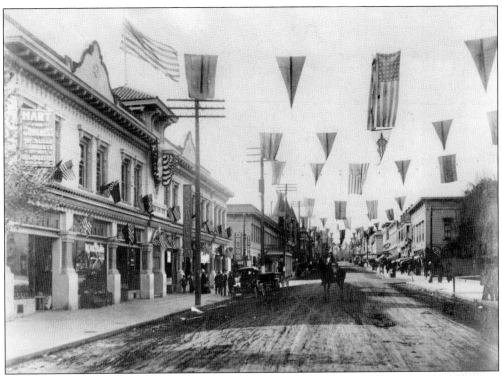

This is an unpaved Fourth Street looking west from midway between A and Court Streets in 1910. The Marin County Bank is on the left.

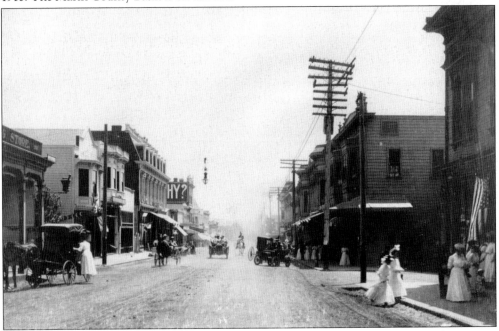

Horses, carriages, and automobiles share the road on an unpaved Fourth Street in this *c.* 1909 photograph. The tall building on the left with the mansard roof was originally the Mahon House, a hotel with San Rafael's most elegant restaurant. This 1875 building still stands.

The Canziani Market at 501 B Street served the Gerstle Park neighborhood for more than 55 years. Peter Canziani opened the market and butcher shop in 1905. He delivered groceries throughout the neighborhood with his horse-and-buggy. Canziani is pictured here with his wife, Josephine. In 1920, his nephew and a partner took over the business. The building still stands.

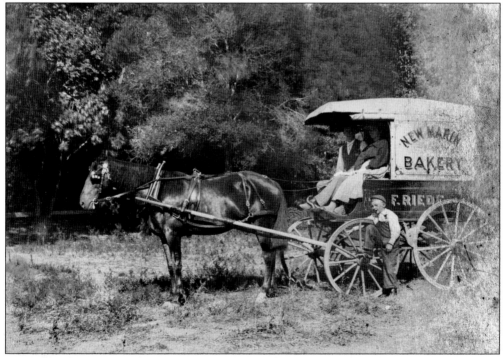

Imagine having fresh, warm bread delivered home for breakfast. In 1898, Frank Riede came to San Rafael, took up baking, and drove his horse-drawn wagon each morning to deliver his goods. Riede sold his successful business in 1915 and planned to retire. However, he soon found himself in the garage and automobile sales business. Riede served as mayor from 1935 to 1937.

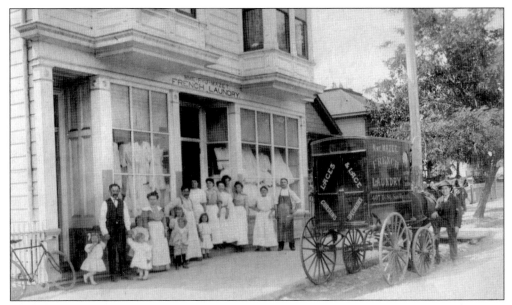

In 1907, Madame Florent J. Mazet purchased a laundry on the west side of D Street between Second and Third Streets. The family lived above the laundry, and the laundry machinery and stable were in the back. Customer accounts included the Dominican Convent and the Hotel Rafael. Madame Mazet is pictured here (the first woman from the left) with her husband (the first man from the left) and their children. Her employees stand to the right.

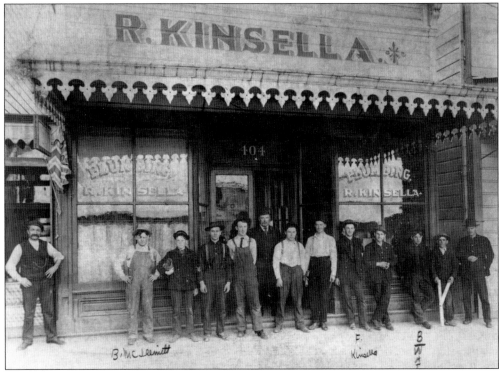

Richard Kinsella opened a plumbing business on B Street in 1879. Kinsella stands in the doorway in the center in this photograph. He became the first elected mayor of San Rafael in 1913.

This is the interior of Gardner's Candy Store on B Street in 1903. Edwin B. Gardner made most of his own candies. He sold the business in 1905 and moved to Lagunitas. Gardner became chief of the Tamalpais Fire District. Gardner Lookout on Mount Tamalpais is named in his honor.

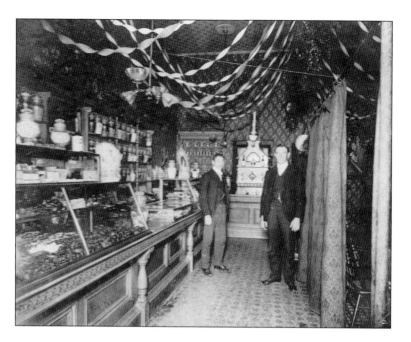

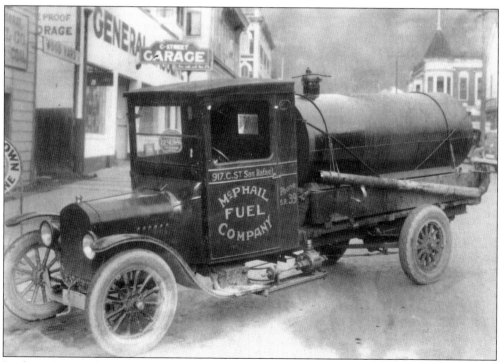

In the 1880s, Neil McPhail opened a successful livery stable; he rented horses and rigs to the guests at the Hotel Rafael. As automobiles began to put liveries out of business, McPhail joined his youngest son, John, in a fuel and coal business. At first, they sold wood and coal, but by 1926, they were using this revamped Ford Model T to deliver fuel oil.

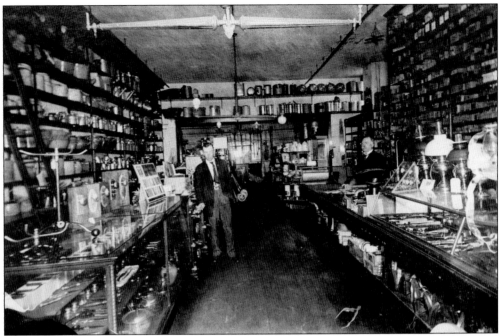

The interior of the Johnson Hardware Company on B Street is in sharp contrast to today's supersized hardware stores. In this 1908 photograph, it appears that one could actually get help in finding the right part or tool from owner Robert W. Johnson (right) and his son Robert J. (left). The elder Johnson served as city treasurer for 10 years and on the board of supervisors for four years.

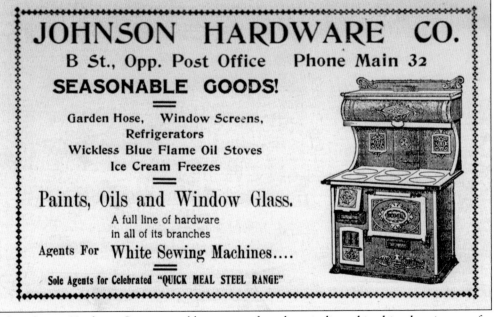

The Johnson Hardware Company sold a variety of goods, as indicated in this advertisement for the store. One might wonder what was quick about the pictured "Quick Meal Steel Range."

Behind the bar is Jacob Blum, owner of Blum's Bar, located on the northwest corner of Fourth Street and Lincoln Avenue, seen here around 1900. The bar was one of many corner establishments selling liquor, wine, and beer.

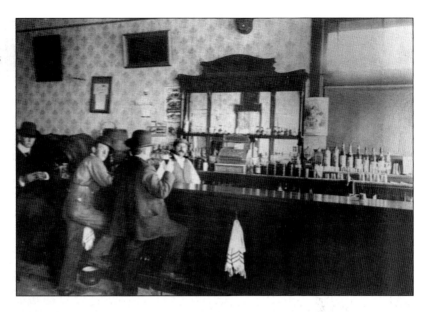

Erskine McNear and Michael Cochrane constructed this building around 1900 on the southwest corner of Fourth and B Streets where a livery had been. In this photograph, Dr. George D. Vanderlip, a dentist, is sitting in the corner window in his second-floor office. Downstairs are a liquor store and a cigar store.

An advertisement for the Mount Tamalpais Natural Mineral Water Company read, "Warranted to be free from all deleterious ingredients and we court the investigation of all pure food commissions. Residences and businesses of San Rafael and vicinity supplied direct from our delivery wagons or through grocers."

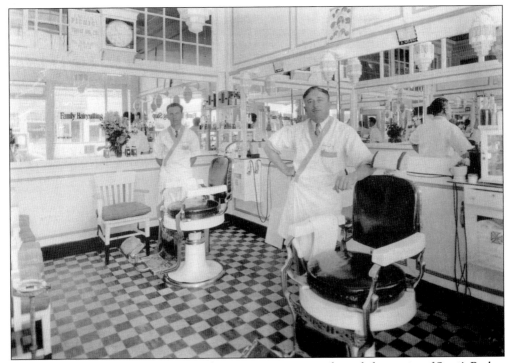

Art Sessi (right) and Ernie Vespi await their next customers in the stylish interior of Sessi's Barber Shop on Fourth Street in 1932.

Eight

ALL FOR THE FAMILY

San Rafael has always promoted its advantages for a healthy family life. From the days of the early pioneers, San Rafael grew as more and more families sought its agreeable climate and a healthy outdoor lifestyle. Families with wealth built great estates and mansions along Mission Avenue and in William T. Coleman's Magnolia Valley, today's Dominican area. Many were used as summer homes, with the families enjoying the long, warm summer days in San Rafael. Elaborate gardens with extensive landscaping were planted. The railroad workers, shopkeepers, and laborers took pride in their more modest cottages and bungalows, each with a profusion of flowers and vegetables in the garden. Roses bloomed year-round everywhere. Many of San Rafael's historic homes are long gone, demolished to make way for a new way of life, but hundreds have been preserved all over the city, adding to San Rafael's charm.

For the family, schools and churches were important social necessities. As the town began to grow around the ruins of the mission, the pioneer families felt the need for a school. James Miller built a schoolhouse in 1849 at Fourth and A Streets; St. Vincent's School for Boys opened in 1855. A number of other private schools started in the 1860s, as the healthy climate in San Rafael made it an ideal location for such ventures. Later two military academies trained boys from all over the Bay Area in mind and body. Dominican College trained young women in the arts and domesticity. San Rafael's citizens pushed for substantial public school buildings and effective education. The first public schoolhouse was completed in 1862, and the first high school in the county opened in 1888. New schools opened as the town grew.

Churches sprang up to nourish spiritual needs. They provided social entertainment and philanthropy as well. The first Protestant services were held in Timothy Murphy's old adobe house or in schoolhouses, but soon fine church buildings were erected. San Rafael was proud of its many steeples, which proclaimed a moral and serious citizenry. San Rafael provided everything needed for a complete family life.

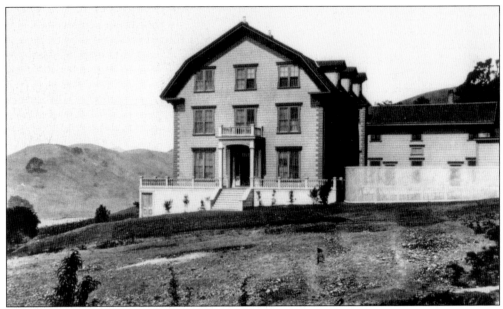

The Mailliard home was built in 1868 by Adolph Mailliard. The house was located partway up the hillside on the western end of town. It was one of the largest homes in Marin when it was constructed. The Mailliards moved to San Geronimo, and the property changed hands twice before Arthur W. Foster purchased it in 1885. Foster named the 135-acre estate Fairhills.

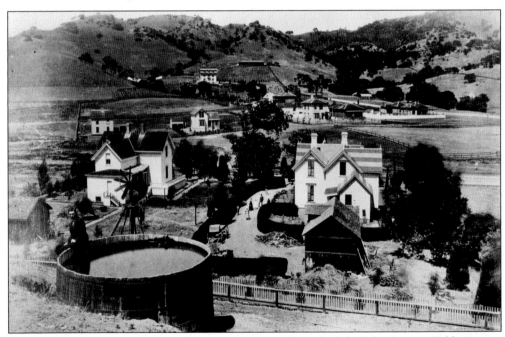

The 1865 Gothic Revival home, in the right foreground, was built by John Sims on Fifth Avenue near Eye Street. The house was moved to Mission Avenue and B Street sometime before 1883. In 1903, it was moved again to 21 Marin Avenue, where it stands today. In the background on the hill is the Mailliard house.

Arthur William Foster (1850–1930) was a shrewd businessman. He was involved in many San Rafael enterprises, including the SF&NP Railroad, the Hotel Rafael, the Bank of San Rafael, and the development of the Coleman tract. He was also a great philanthropist, making sizeable donations to the San Francisco Theological Seminary, the Mount Tamalpais Military Academy, and the San Rafael Improvement Club. (Courtesy San Francisco Theological Seminary.)

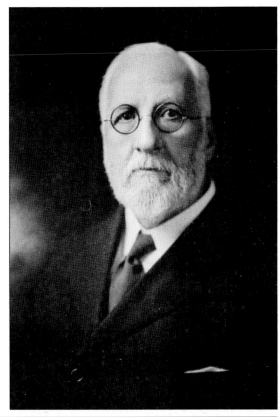

Arthur W. Foster and his wife, Louisiana Scott, lived at Fairhills with their nine children. The Fosters remodeled the house and added extensively to the gardens. The estate, shown here in 1893, included a three-story barn, laundry, gate house, pond, vineyard, orchard, and children's recreation area. It was truly one of the showplaces of San Rafael.

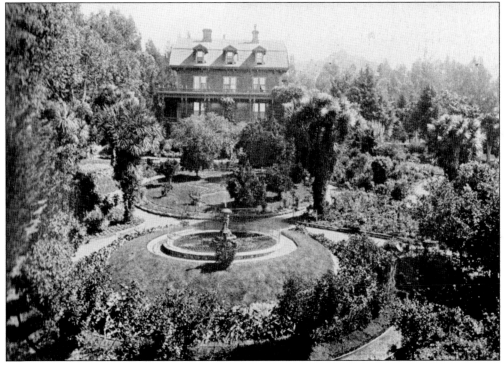

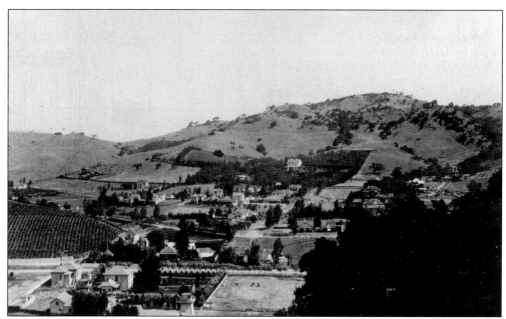

The Foster's Fairhills estate of 135 acres can be seen in the center background in this 1899 panorama of the west end of San Rafael. Fourth Street is in the foreground, with the vineyards of Zopf's Family Resort rising on the hill on the left.

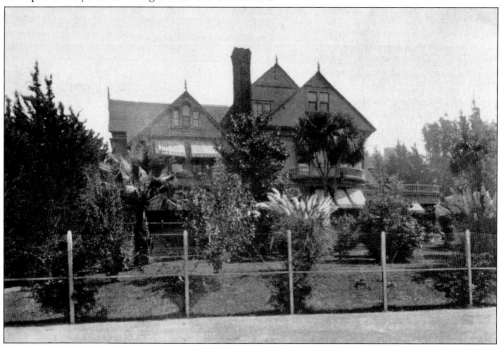

At the corner of Magnolia and Palm Avenues in the Dominican area is Edgehill, constructed in 1887 by William and Helena Babcock. The Dominican Sisters purchased the Queen Anne Victorian in 1920. The house served as a residence and dining hall and later as classrooms and offices before the university was forced to close it due to structural problems. Plans are underway to restore the beautiful house.

Meadowlands, shown here in 2000, was built in 1888 as a summer home by Michael H. de Young, founder of the *San Francisco Chronicle*. It was remodeled in 1900 with Clinton Day as the architect. Meadowlands was the scene of many lavish parties given by the de Youngs. The house was sold to the Dominican Sisters in 1918. Today it is a residence hall.

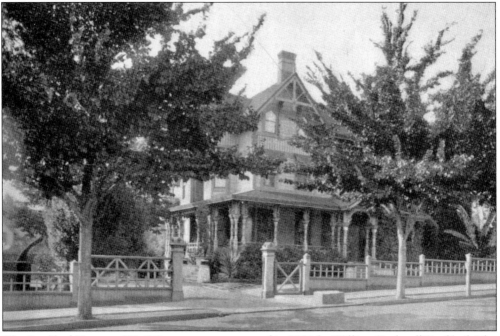

The Bradford House at 333 G Street was constructed in 1883 for William Bushnell Bradford. The Stick/Eastlake house has been divided into apartments for many decades. The house is listed on the National Register of Historic Places.

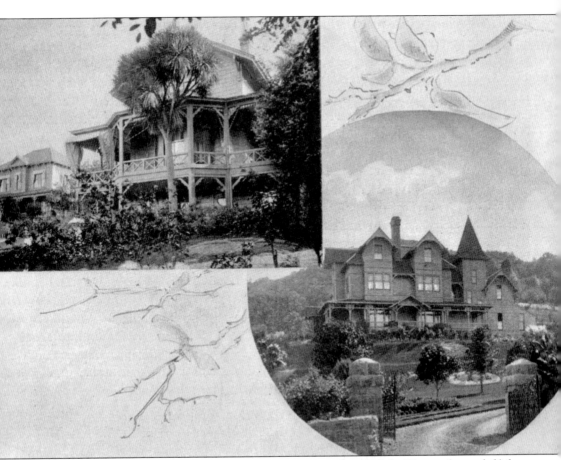

Lewis Gerstle, a successful San Francisco businessman, purchased Violet Terrace (upper left) from Asa C. Nichols in 1881 for use as a summer home. The estate was on the hillside at the southern end of town. The Gerstle family continued to use the vast estate, with its gardens, multiple dwellings, stables, tennis court, and barns, until 1930 when the family donated it to San Rafael for use a public park. Louis Sloss, Gerstle's brother-in-law and business partner, purchased the adjacent property to the east of Violet Terrace. Architect John Wright designed a large wooden house (lower right) in 1883 for the Slosses. The Sloss heirs donated the property to the Evangelical Synod of North America for use as a retirement home. In 1955, the house burned in San Rafael's worst fire; eight people died. Part of the Sloss estate survives today as a bed-and-breakfast inn.

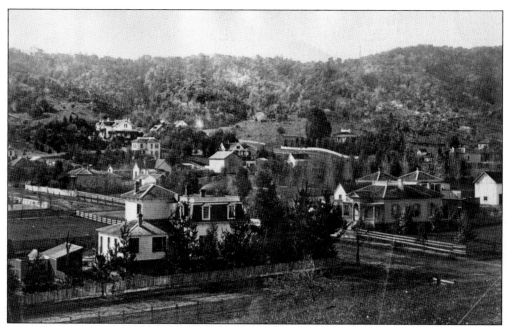

Violet Terrace, purchased by Lewis and Hannah Gerstle in 1881, is the large white house on the hill on the left in this early 1880s photograph of the Gerstle Park area. The house directly below Violet Terrace was built by Anson Hotaling, who had made his fortune in the liquor business in San Francisco. He was a prominent San Rafael banker and owned the quarry at San Rafael Avenue and Clark Street.

William Lichtenberg, a German rice planter from Java, was appointed German consul in San Francisco. In 1874, he purchased 10 acres from William T. Coleman in Magnolia Valley. John Sims built the house for the Lichtenbergs on Locust Avenue. It was enlarged substantially in 1886 by William Curlett, a San Francisco architect. The Lichtenberg family owned the home for 84 years, and many people lived with or boarded with them over the years.

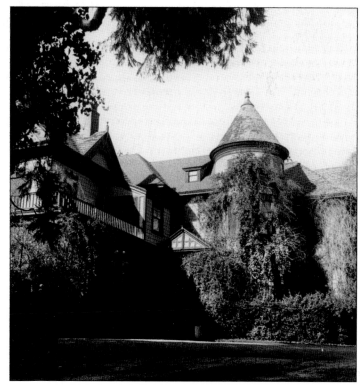

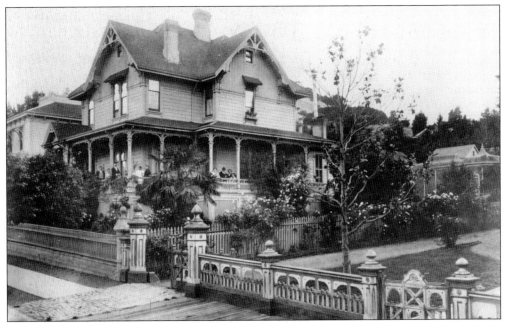

The restored Eastlake Victorian house at 828 Mission Avenue was originally built in the early 1880s for Edward W. McCarthy, a coffee and spice merchant. McCarthy was elected to the city's board of trustees in 1893. The house was sold to Maxmillian Herzog, a local butcher, in 1896. Herzog suffered from chronic asthma and had been forced to move from San Francisco to San Rafael's warmer climate in 1878.

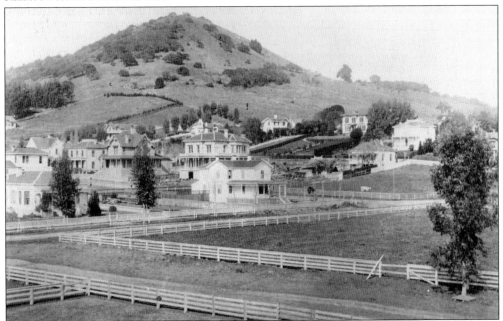

This photograph from the 1880s was taken from the intersection of Fifth Avenue and Petaluma Road (today's Lincoln Avenue). The second house on the north side of Mission Avenue is the McCarthy House. The two-story Italianate house on Laurel Place was the home of Thomas Wintringham; San Rafael Hill rises above.

John Franklin Boyd (1842–1920) formed a partnership with Seth and Dan Cook, and bought a mine in Bodie, California, that yielded a bonanza. He married his partner's niece, Louise Cook Arner, who inherited the Cook estate in San Rafael and an estate in Contra Costa County. Boyd continued to accrue assets through his skilled management, and the family enjoyed a charmed life. The Boyds took part in community affairs and shared their time between the two estates.

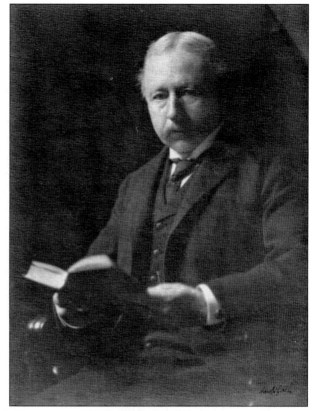

Louise Arner Boyd and her three children, (from left to right) Louise, Seth, and John, are pictured here around 1893. The children had an ideal life romping in the large home and riding ponies around San Rafael. Then tragedy struck in 1901; within a year, the two boys died of heart disease caused by rheumatic fever.

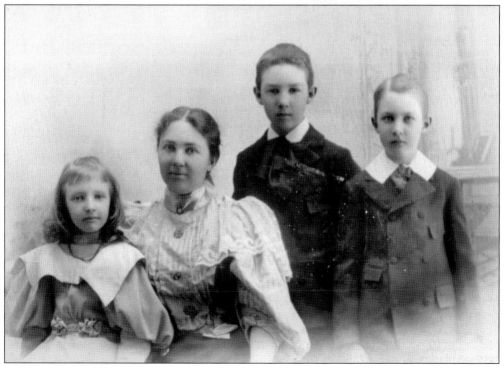

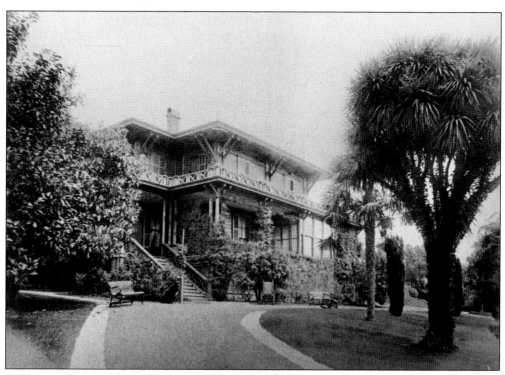

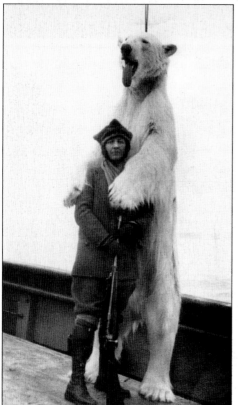

Maple Lawn was the name of the Boyds' estate in San Rafael on Mission Avenue. The Cooks, who originally owned the house, had made extensive improvements to the property. Seth Cook bought six acres and added the Gate House at the entrance to the drive in 1879. Today the Elks Club owns Maple Lawn.

Louise Boyd inherited all the Boyds' assets when her parents died. A trip to the Arctic in 1924 determined her future life, and she became an Arctic explorer. Louise financed seven expeditions to Greenland and surrounding areas for which she acted as the photographer. After the start of World War II, she came home to San Rafael and became involved in social and civic activities. This photograph was taken on a 1926 hunting expedition.

Robert Dollar was born in Falkirk, Scotland, in 1844. His family immigrated to Canada when he was 12 years old to escape poverty. Dollar pulled himself up from his poor beginnings to become a wealthy lumber mill owner. He went on to establish the Dollar Steamship Lines, which made him known throughout the world. Captain Dollar died in 1932, and his many mourners and tributes proclaimed his worldwide importance.

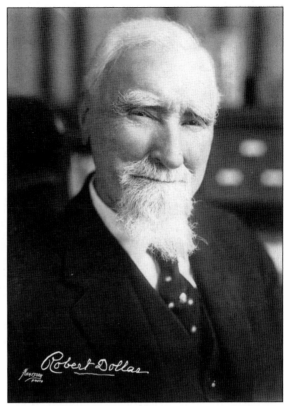

Robert Dollar

The Dollar family moved into their home, called Falkirk, in 1906. The house, designed by Clinton Day, was built for Ella Nichols Park in 1888. The Dollar family lived on the beautiful 11-acre estate until 1970. The house was scheduled to be torn down, but a local group fought to save it. Falkirk is on the National Register of Historic Places and currently serves as the Falkirk Cultural Center, which is owned and operated by the City of San Rafael.

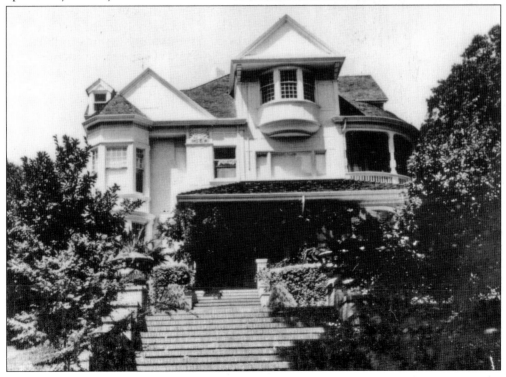

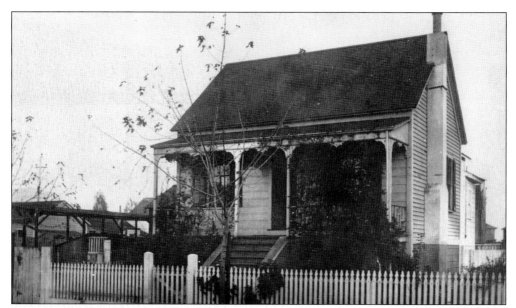

In the early 1870s, Hans Iverson purchased this home on the corner of E and Frances Streets. Iverson, a native of Denmark, was a coal and wood dealer. He built a landing along San Rafael Creek at First and D Streets from which goods were unloaded from scows. The house still stands.

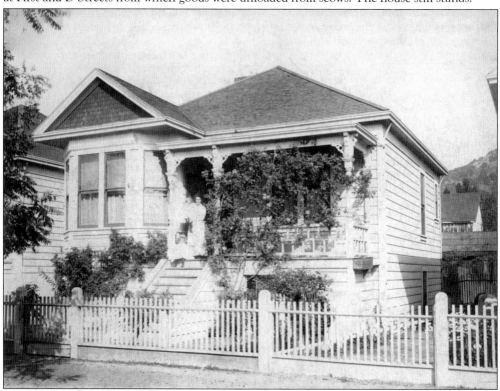

The house at 14 First Street was purchased by William O. Smith, a San Rafael village blacksmith, in the late 1890s. Smith and his wife, Alice, raised three sons and four daughters in the modest home. Roses grew everywhere in San Rafael, and a climber shaded the front porch of the Smith home.

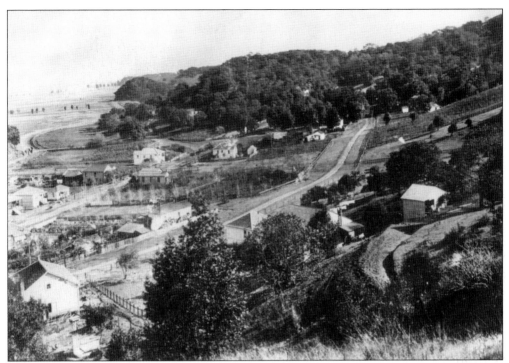

This photograph was taken from the hillside behind the home of Abondio Granzella at 225 Picnic Avenue in 1912. Picnic Avenue is the road in the center, and Woodland Avenue is on the left.

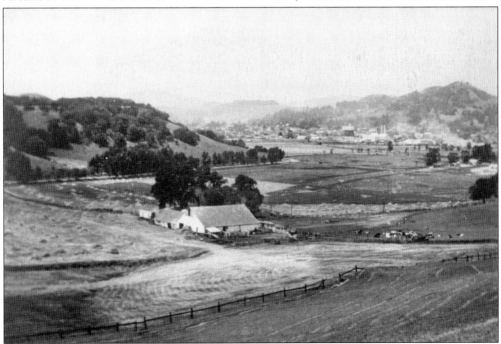

Some of San Rafael remained rural into the 1930s. The cows, barn, and pastures of the Redding Ranch in Bret Harte are shown in this 1928 photograph. The ranch land was subdivided in the early 1940s as Bret Harte Meadows.

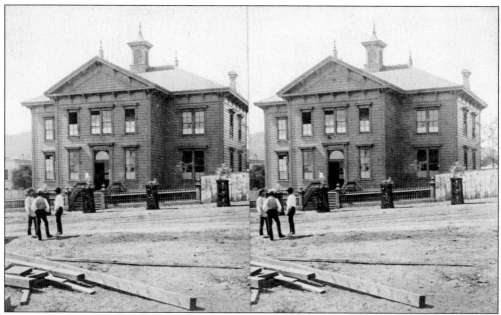

The B Street School, shown in this stereographic image, was completed in 1870 at a cost of $3,250. San Rafael's first publicly built schoolhouse, a modest, one-room building, had been constructed in 1862 on a donated lot on the southwest corner of Fifth Avenue and B Street. This new two-story building was constructed on the same lot.

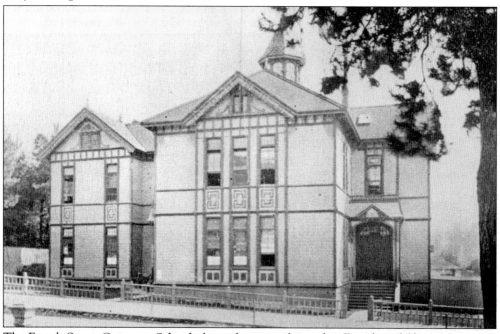

The Fourth Street Grammar School, shown here, was located at Fourth and Shaver Streets. It was completed in 1886. There were no public high schools in the county until 1888, when the first class was held in one room of the Fourth Street Grammar School. In 1891, the first high school class to graduate held their graduation at Gordon's Opera House, as many succeeding classes were to do.

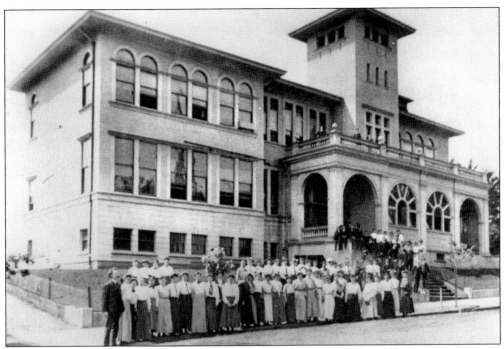

By 1898, there were 60 high school students, and the need for a new school was evident. A. W. Foster, one of the county's great benefactors, bought the entire issue of school bonds. A new high school, shown here around 1910, was built on E Street between Third and Fourth Streets in 1899. It had 15 classrooms and a large gymnasium that could also be used as an assembly hall.

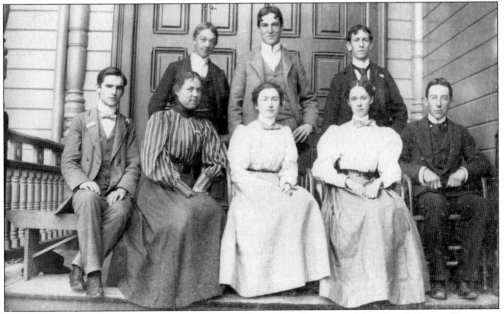

The 1898 senior class of San Rafael High School poses on the steps of the Fourth Street Grammar School. Seated from left to right are (first row) Ray Brown, Sarah Lunny, Mae Olin, Katie Kinsella, and Will Scott; (second row) Max Schmidt, Arthur Studley, and George Herzog; (absent) Annie Strain and May Clifford.

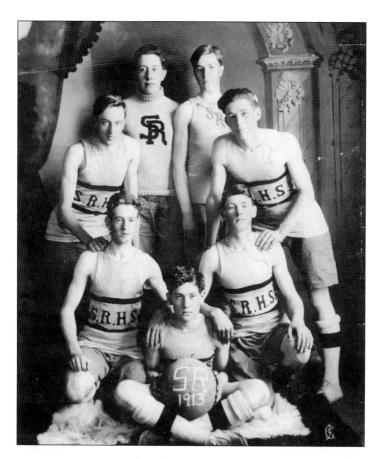

Boys' athletics were part of the program at San Rafael High School from the beginning in 1899, and they competed with the local private academies.

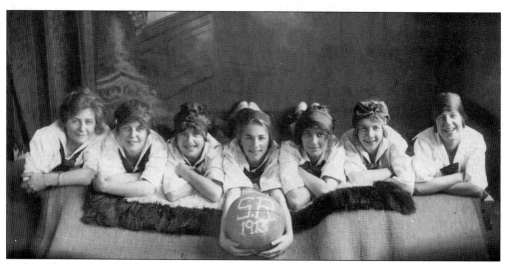

Girls' athletics were added to the program at San Rafael High School in 1909. The 1913 basketball team is shown here.

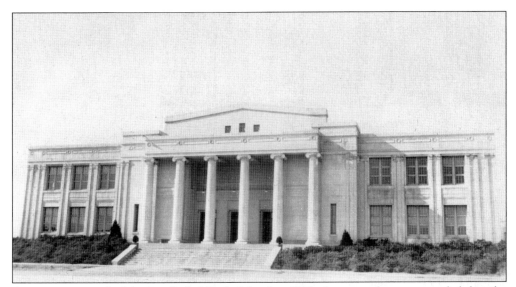

A new site was picked for San Rafael High School in 1923 when a study recommended that the school on E Street be abandoned. The new school was designed by Shea and Shea architects and was constructed at a cost of $300,000. The school opened in 1925 on Mission Street at the east end of town in an area called Happy Valley.

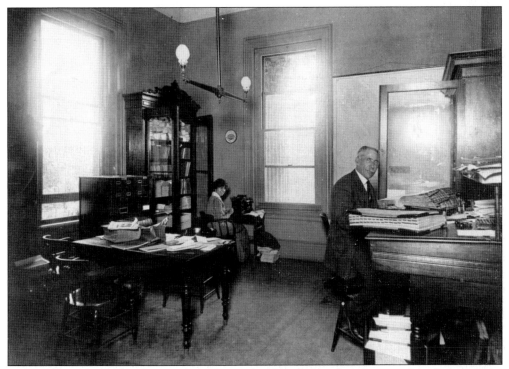

James B. Davidson, shown here in his office in the old courthouse with an unidentified secretary, was the Marin County superintendent of schools from 1903 to 1934. Davidson received training as a teacher in Canada and came to Marin County in 1887. He was known for his progressive ideas and effective leadership skills. James B. Davidson Middle School is named in his honor.

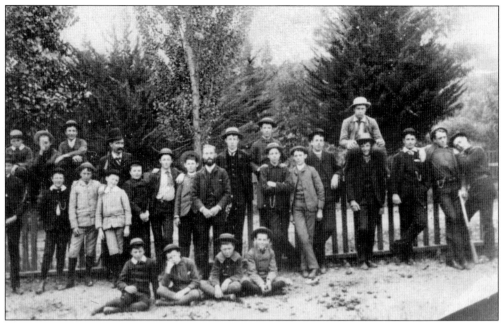

San Rafael College, a preparatory school for boys established in 1878, was turned over to Octavius John Seymour Cavendish Bates in 1888. A three-story school was built on Clark Street. Bates named the school the Selbourne School, but it was known simply as Bates's school. This is a photograph of the students in 1888.

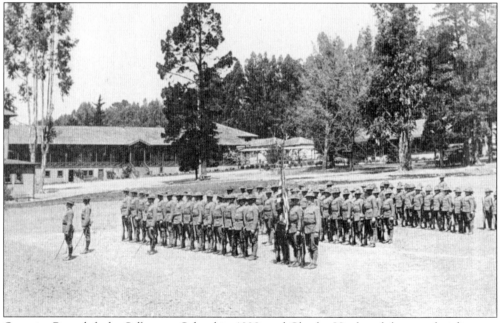

Octavius Bates left the Selbourne School in 1898, and Charles Hitchcock became headmaster. In 1899, the school burned to the ground. Hitchcock rebuilt on Grand Avenue between Elm Street and Belle Avenue. The school became known as the Hitchcock Military Academy. It operated until 1925, when it was purchased and renamed the Tamalpais School for Boys, a nonmilitary academy.

Mother Louis O'Donnell was responsible for relocating the Dominican convent and school from Benicia to San Rafael. She was born Catherine (Kitty) O'Donnell in New York in 1852 and was raised in Calaveras County, California. She entered the Dominican Convent in Benicia in 1868 at the age of 16. She served as principal of St. Vincent's Academy in Vallejo before being elected Mother Provincial by the Dominican Sisters in 1887.

William T. Coleman donated half the cost of 10 acres in his Magnolia Valley for the new Dominican convent and school for girls. It opened as the College of San Rafael in 1889, and this photograph was taken soon afterward. Designed by well-known church designer and prolific San Francisco architect Thomas J. Welsh, the ornate, four-story, Victorian building was constructed entirely of redwood.

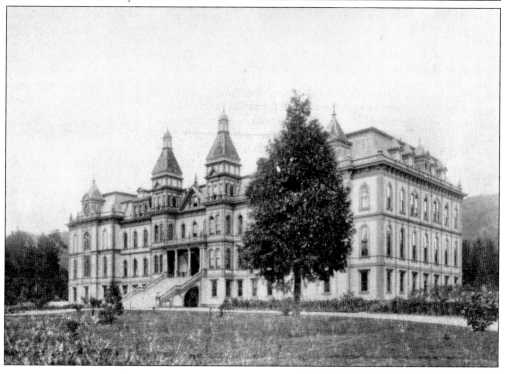

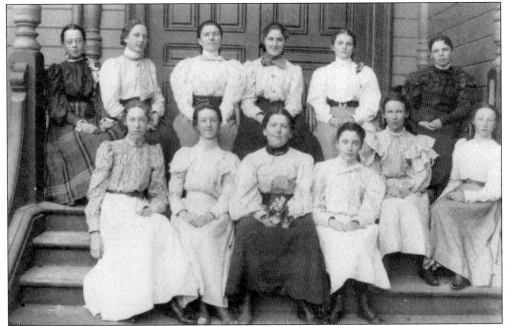

Pictured around 1897, these Dominican students are, from left to right, (first row) Una Loudon, Rose Peters, Alice Ross, Agnes Becely, Eleanor Giloghy, and Gertrude Ring; (second row) Pearl Gould, Iridie Cheda, Helen J. Sheehy, Elizabeth Dufficy, Martha Nichols, and Ada Lecombie.

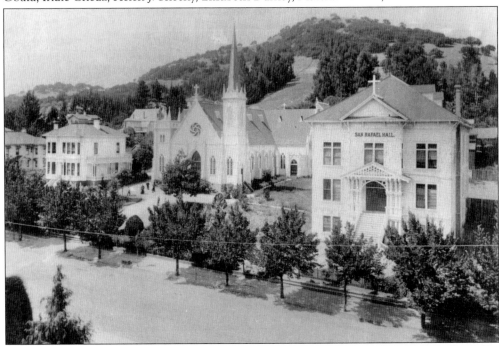

St. Raphael's School opened in 1889 on Fifth Avenue and A Street. Teaching was conducted by the Dominican Sisters who had recently moved to San Rafael. The building was three stories tall with offices on the first floor, classrooms on the second, and a meeting hall on the third. It was designed by Thomas J. Welsh, who also created the Dominican Convent.

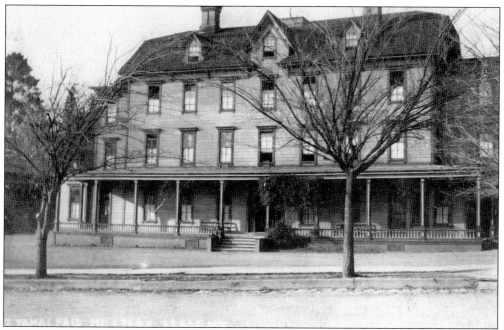

The Reverend Charles F. Miel came to San Rafael about 1866 and started the first academy for girls on the hill above Mission Avenue. Miel sold the property to Michael J. O'Connor in 1868. O'Connor had the building moved to Fifth Avenue. A third story was added, and the building was converted to the Tamalpais Hotel. In 1891, the property was acquired by the Mount Tamalpais Military Academy, and the building served as the barracks.

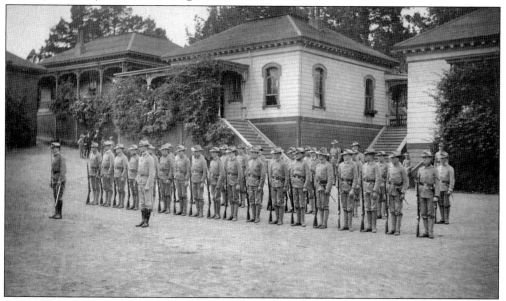

Mount Tamalpais Military Academy was founded in 1890 by Dr. Arthur Crosby. When Crosby died in 1915, a former graduate, Newell F. Vanderbilt, took over. The school had a reputation for excellent training and high academic standards. The military students provided excitement when they participated in parades, and the young women of San Rafael eyed them as potential escorts and suitors. The school was sold in 1925 and became the San Rafael Military Academy.

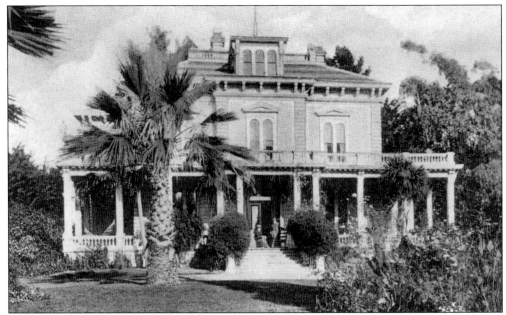

Michael J. O'Connor, a wholesale hardware merchant, built a home on the hill above Mission Avenue in 1868. It was purchased by Arthur W. Foster in 1891 and was donated to the Mount Tamalpais Academy. The home was renamed Foster Hall. It was later remodeled and stands today on the grounds of Marin Academy.

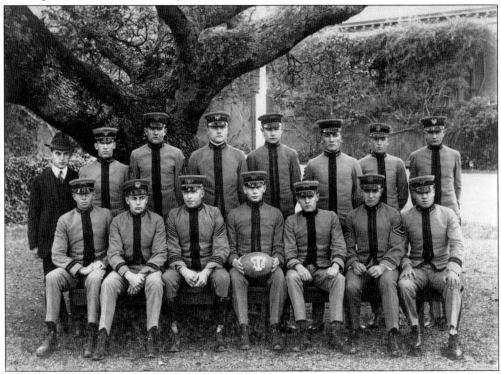

The Mount Tamalpais Military Academy class of 1918 poses under the branches of a large oak tree. The gracious oak still stands on the Fifth Avenue side of the Marin Academy Library.

St. Paul's Episcopal Church was formed in 1868. The church, shown here, was built in 1869 at Fourth and E Streets. It was the first Protestant church building in San Rafael. When the school next door wanted to expand, the church had to move. In 1924, a lot on Mission Avenue and Court Street was purchased. The church building was cut in two and moved down Fourth Street. The only accident was that the organ fell off the moving truck and was smashed. Stucco was applied over the frame exterior to make the church fireproof.

The First Presbyterian Church of San Rafael was dedicated in January 1876. The church was located on the west side of E Street between Third and Fourth Streets. Many well-known pioneers attended this church, including Ai Barney, Harriet Shaver, and Euphemia Murray. When the Presbyterians decided to build a new church in 1897, the Congregational Church bought the building and held services there for the next 65 years.

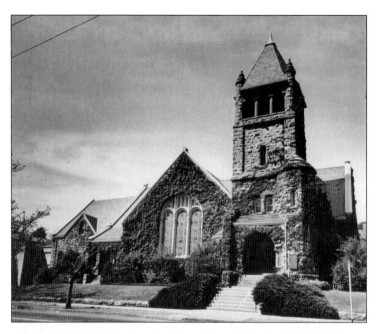

A new Presbyterian church was built on the northwest corner of Fifth Avenue and E Street in 1896, with Ella Park contributing $20,000 to build the handsome stone structure. The stone came from the Hotaling Quarry on Clark Street. In the 1960s, concerned church members decided to demolish the stone church because it did not meet seismic requirements.

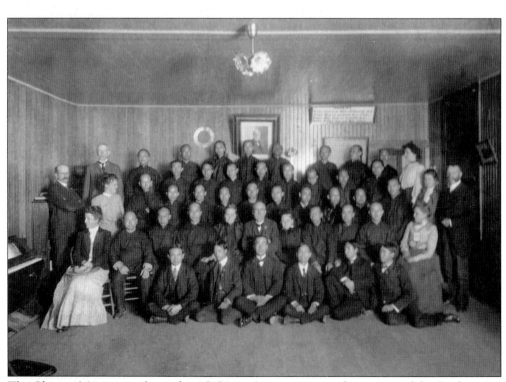

The Chinese Mission was located on C Street. It was an outreach program of the Presbyterian church. In 1902, a building was purchased that provided a gathering place for Chinese residents and a place to learn English and about the Christian church. The Chinese in California were discriminated against and were not welcome in many social settings. (Courtesy San Francisco Theological Seminary.)

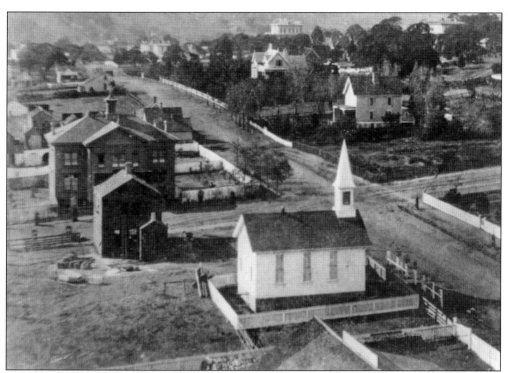

The United Methodist Church was the first Protestant group to hold services in San Rafael, beginning in 1851. This 1870s photograph, looking west along Fifth Avenue at B Street, shows the Methodist church in the foreground. The church was dedicated on February 18, 1871. In 1880, the building was moved to Fourth Street between D and E Streets.

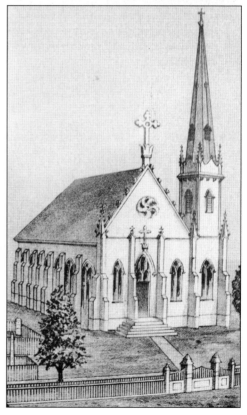

After Mission San Rafael Arcangel fell to ruin, a small chapel to serve the community was built in 1855. The congregation outgrew the little church, and a new, larger church, depicted in this lithograph, was constructed and dedicated on October 22, 1870. Father Lagan enlarged St. Raphael's and added many improvements in 1889. When the church was destroyed by fire in 1919, an immediate effort to rebuild was undertaken by the church members.

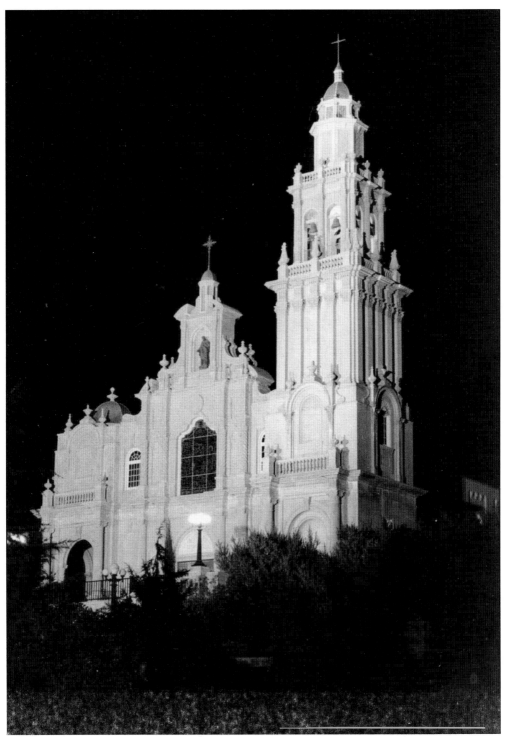

The Most Holy Rosary Chapel at St. Vincent's School for Boys was completed in 1929 and was dedicated on June 29, 1930, in celebration of the 75th anniversary of the school. The striking Italian Renaissance Revival–style church was made possible through an anonymous donation.

Nine

TIME TO PLAY

From the earliest times, San Rafael has been a place for fun and recreation. Timothy Murphy hosted many parties in his adobe home, where guests feasted and drank while telling tall tales of adventure in early California. In those early days, the celebration of St. Raphael's Day was held on October 24. From all over the county, vaqueros, Native Americans, foreigners, and priests came together for sport and entertainment. The best horsemen showed off their trick riding, the ladies were excited by the fandango, and best of all was the bullfight that never quite lived up to expectations. Days of revelry gave way to sore heads and a return to ordinary rancho life.

After statehood, the picnic trains and excursionists sought out San Rafael's natural beauties. The city's businessmen promoted summer tourism. They wished for a first-class hotel to bring a prosperous clientele. The Hotel Rafael was just such a place. The climate of San Rafael and the ease of transportation made the hotel a success when it opened in 1888. San Rafael was suddenly the place to be for a summer vacation. Homes and cottages were rented for the summer, and the town filled up with vacationers glad to see the sun. The wealthy promoted golf and country clubs for their entertainment. The San Rafael Baths provided refreshment for everyone on hot summer days. The young and old lined up to spend time swimming and socializing at the municipally owned swimming pool. Other activities around San Rafael included bicycling, hiking, and trips by carriage or horseback. Baseball and tennis were favorites with the young and vigorous.

The movies came to town in 1912 when the California Motion Picture Corporation chose San Rafael as the site for its studio. All the excitement of the movies and movie stars elated local residents. Movie theaters became big business. The theaters started out as nickelodeons, but soon beautiful movie palaces were built. The long, warm days of spring, summer, and autumn gave residents and tourists alike time to enjoy the many activities that San Rafael had to offer.

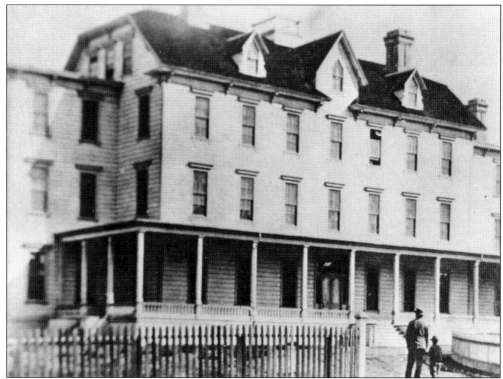

The Tamalpais Hotel at Fifth and E Streets started out as a school but was remodeled and opened as a hotel in 1871. It was a first-class hotel meant to draw visitors to San Rafael. In 1891, it was purchased by the Mount Tamalpais Military Academy for use as its barracks.

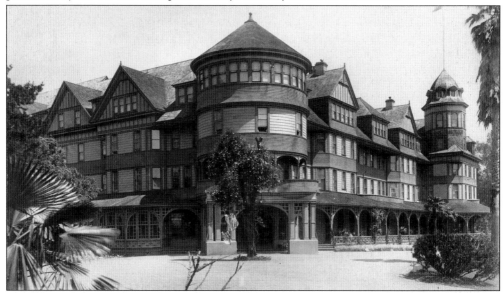

The Hotel Rafael opened in 1888 and fulfilled the dreams of San Rafael businessmen for a first-class resort hotel. It had 100 rooms, dining rooms, and verandas. The grounds boasted rose gardens, a maze, and tennis courts. The elite flocked to the new hotel to stay the summer and enjoy the sunshine in San Rafael.

There were views of the San Francisco Bay and the surrounding hills from the observation tower of the Hotel Rafael. Pillars marked the drive at the main Irwin Street entrance. Two of the pillars still stand at the corner of Belle Avenue and Rafael Drive.

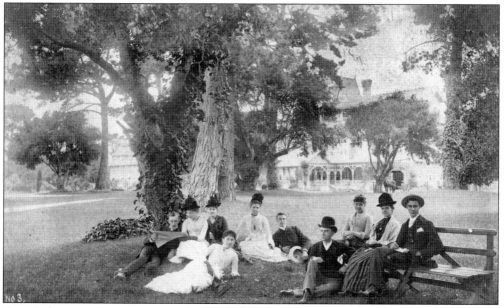

A typical group of young guests at the Hotel Rafael enjoy the landscaped grounds in this 1890s photograph. Perhaps the couples were plotting a rendezvous in the rose garden or a few moments alone at the top of the observation tower.

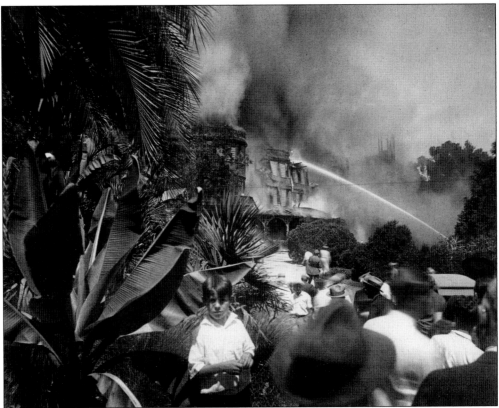

On July 29, 1928, a fire started on the top floor of the Hotel Rafael, and the hotel burned to the ground in two hours. Fire departments from San Rafael and other cities were called to the scene, but in the end, a few brick chimneys were all that was left of the former glory of the hotel.

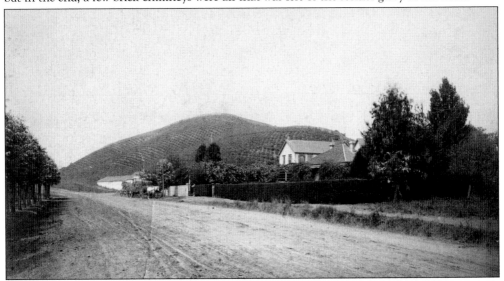

Herman Zopf, a native of Germany, settled in San Rafael in 1867. Zopf's Family Resort, with vineyards and a wine garden, was a popular spot at the west end of town at Fourth and H Streets. This is Fourth Street looking west in 1876. Zopf's vineyards rise on the hill behind.

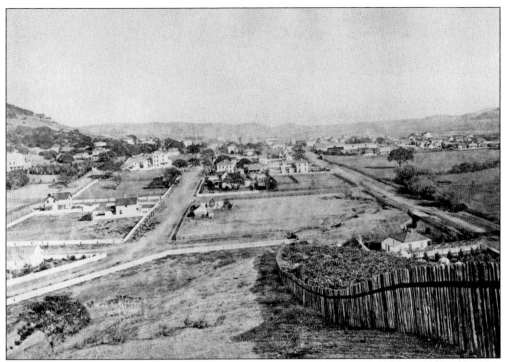

Zopf's Family Resort can be seen in the lower right in this *c.* 1875 photograph of San Rafael. Fourth Street and Fifth Avenue run east to downtown from H Street. Zopf's was a short walking distance from the NPC Railroad station at West End.

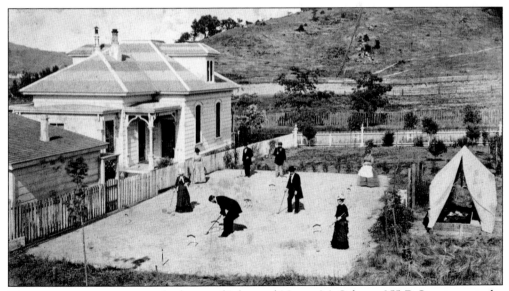

The croquet game set up at the home of John and Nancy McCabe at 255 D Street was to be followed by teatime in the little tent. This was a pleasant way to spend a summer afternoon in the 1880s.

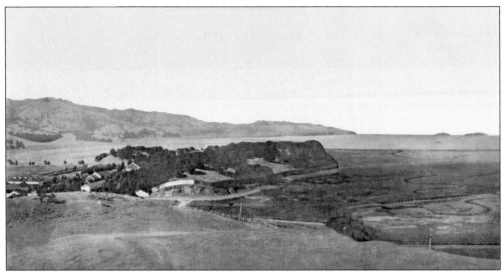

The Schuetzen Park opened on April 5, 1891, in east San Rafael. It was a private club for German Americans. The famed marksman Philo Jacoby was the president of the club and led the rifle competition. Later the park name was changed to the California Park because of anti-German feelings during World War I.

The great bicycle race was held in San Rafael on September 13, 1896. Frank Byrnes, a professional bicycle rider, organized the event, inviting bicycle clubs from all over the Bay Area. The riders pose at the courthouse, which was the terminus of the race.

Every town in Marin had its own baseball team. The San Rafael Baseball Club won the Sonoma–Marin championship in 1905. Pictured from left to right are (first row) ? Esola; (second row) Hap Hogan, "Chief" Esola, Jack Sims, and Jim Sullivan; (third row) Pete Pedrotti, "Dimp" Burns, Ed Nelson, Jim Nealon, Gene Hawkins, Rudy Lichtenberg, and Bill Hunter.

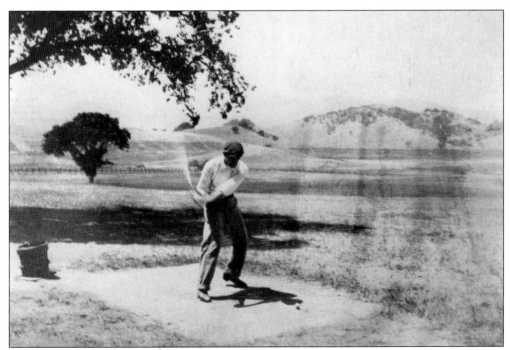

Alex Bell takes a swing at the San Rafael Golf Club in Santa Venetia. The club was one of the earliest golf clubs in California. The nine-hole course opened in 1898.

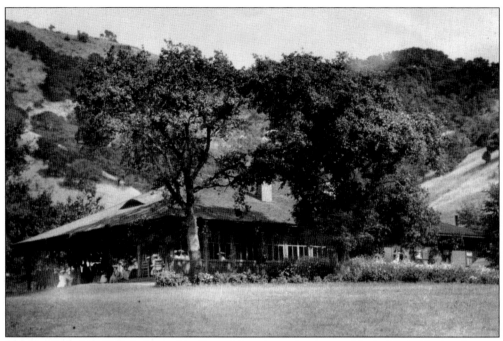

The San Rafael Golf Club, located in Santa Venetia on the present Marin Civic Center site, was popular with the summer tourists. The club even had its own railroad stop called "Golf."

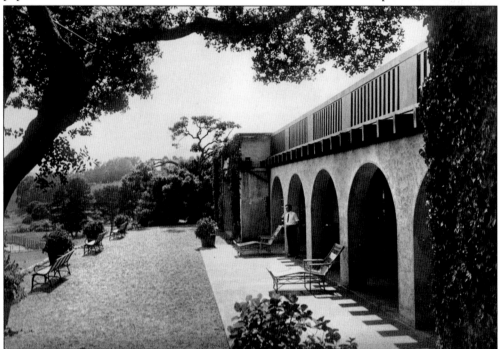

The Marin Golf and Country Club opened on September 12, 1908. It was located east of San Rafael High School on San Pedro Road. It was a real country club with a swimming pool, clubhouse, and restaurant. The course was only nine holes however, and when the Meadow Club opened in 1927 with 18 holes, the club lost its popularity and eventually closed in 1939.

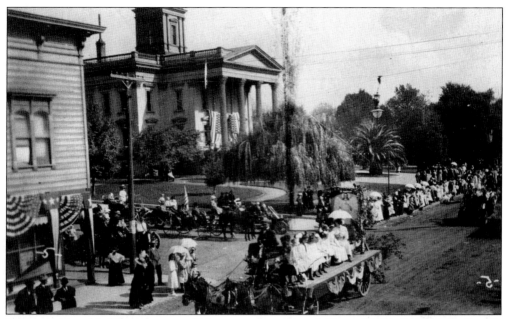

On any national holiday, there would be a parade on Fourth Street in San Rafael. The Fourth of July parade was the biggest and most popular parade, with businesses decorated with bunting and pretty girls on floats pulled by horses. The Marin County Courthouse in the background is decorated with American flags.

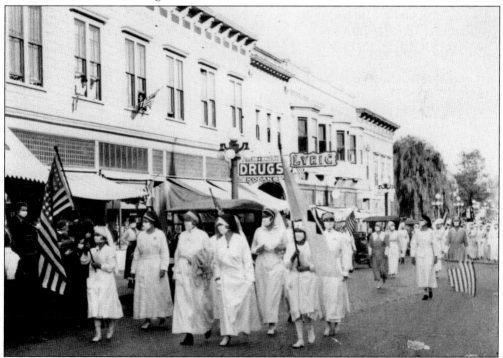

The parade pictured here took place in 1918 when the Spanish influenza was running rampant through the country. It was mandatory to wear gauze masks to cover the mouth and nose to prevent spreading the disease.

The California Motion Picture Corporation was formed in 1912. The company chose San Rafael for their location because of the perfect weather and scenic beauty. The studio buildings were constructed in Sun Valley with a background of grassy hills.

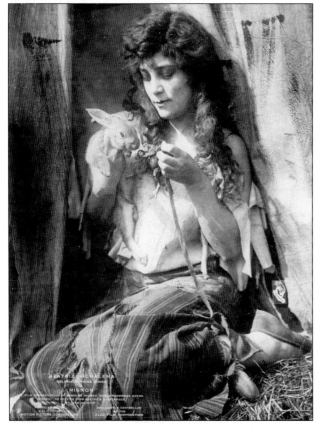

Beatriz Michelena was the star of the California Motion Picture Corporation's silent films. She married George Middleton, the producer, and together they made many silent films such as *Salomy Jane* and *Mrs. Wiggs and the Cabbage Patch*.

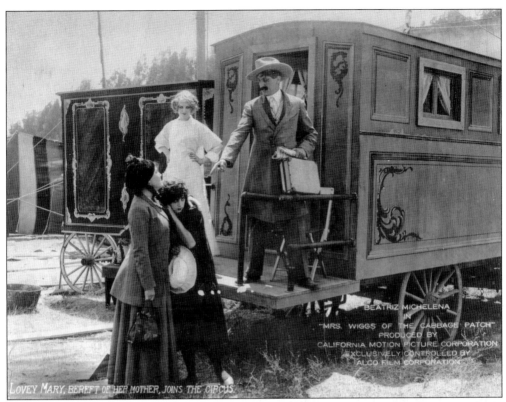

LOVEY MARY, BEREFT OF HER MOTHER, JOINS THE CIRCUS.

Mrs. Wiggs and the Cabbage Patch was filmed in San Rafael. The film had a circus theme, and the townspeople played the circus audience. When the film came out, everyone went to the theater to see it and stayed to see it again.

Leon Douglass was a lifelong inventor. With a partner, Douglass formed the Victor Talking Machine Company. Douglass moved to San Rafael in 1906 and continued to invent special methods of filming for motion pictures. He patented the process for color filming in 1916. He was interested in San Rafael and contributed funds to many civic projects, including the San Rafael Municipal Baths and the San Rafael Improvement Club.

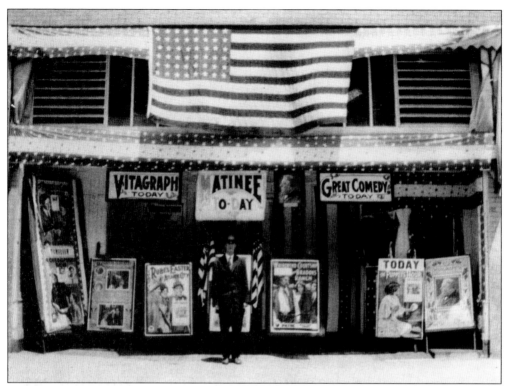

The Victory Theater opened in 1920 and showed early motion pictures. The competition between movie theaters was intense, and they regularly went out of business and then reopened under new management.

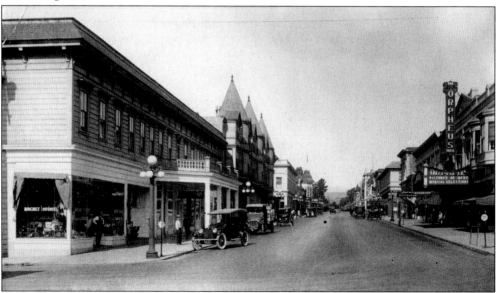

The Orpheus, on the right in this view of Fourth Street looking west from A Street, was the first theater to be built as a movie theater. It opened for business in January 1920. This was the era of the movie stars, and a standard program would be two films and several short features that changed five times a week. The theater burned in 1937 and was replaced by the Rafael Theater.

The El Camino Theater was built in 1928 on Fourth Street in the grand manner of movie palaces. The decor was opulent, with wide, sweeping stairways, chandeliers, and gold-encrusted walls and ceilings. It was the showplace of the Marin theater circuit. When television invaded the United States, the movie palaces fell on hard times. The theater was stripped of all its glory in 1953 when it became a JCPenney store.

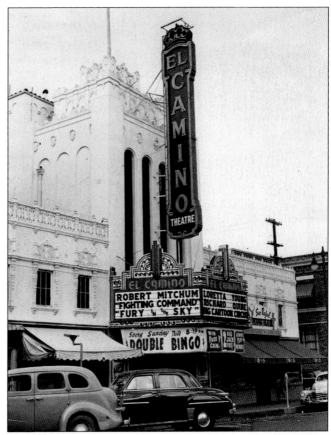

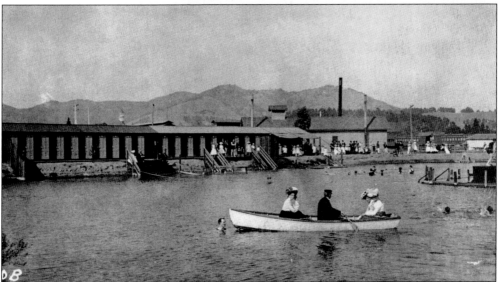

In 1901, Charles P. Ware leased property on the San Rafael Canal for 10 years. He erected a bathhouse and office, and ran the open-air baths. It was a popular place for swimming and boating. After 10 years, Ware gave up the lease. The bathhouse dressing rooms line the bank on the left.

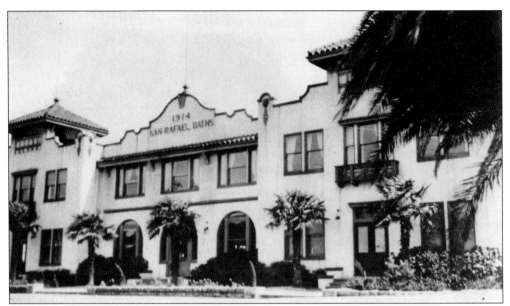

Two thousand visitors flocked to the San Rafael Municipal Baths on opening day, Sunday, April 18, 1915. The bathhouse was located at Second and Irwin Streets. Architect Thomas O'Connor designed an elaborate filtration system. Regular inspections were made, and bacterial counts were reported to the city council.

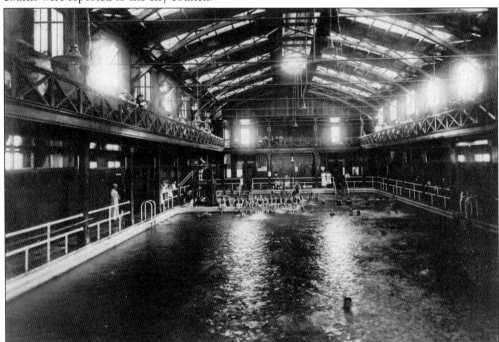

The main tank of the San Rafael Municipal Baths was 50 feet by 120 feet. Water depth ranged from 20 inches to 9 feet. On the main floor were 118 well-equipped dressing rooms, showers, and lavatories. The floor above had a balcony that encircled the interior of the building. The most exciting choice for entering the pool was the slides from which swimmers plunged into the water from the balcony level.

Eleanor Garatti, an Olympic medal winner in 1928 and 1932, began her swimming career at the San Rafael Municipal Baths. In 1928 at the age of 19, she won the gold medal in the 400-meter freestyle relay event and the silver medal in the 100-meter freestyle event. San Rafael welcomed the hometown heroine with a brass band when she returned.

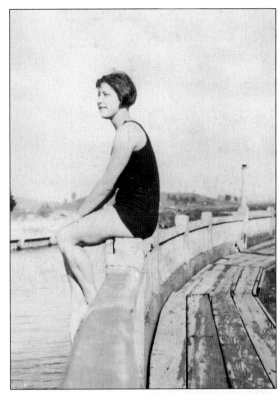

Billy Shannon's Villa was a popular gathering place on the west end of Fourth Street in the early years of the 20th century. It was a saloon and boxing training camp where some well-known fighters trained. Shannon, a former amateur lightweight champion on the Pacific Coast, moved his training camp to San Rafael after the 1906 earthquake. Fans would arrive at the West End train station and walk the short distance to Shannon's. Some of them are gathered outside in this photograph; Billy Shannon stands fourth from the right.

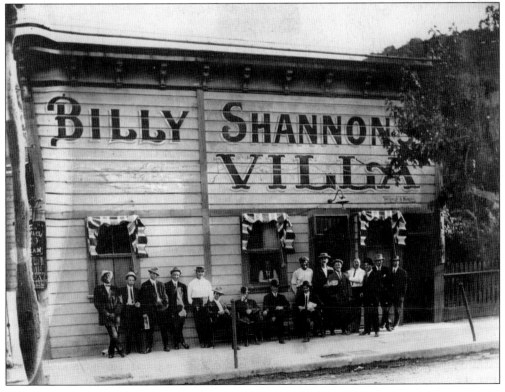

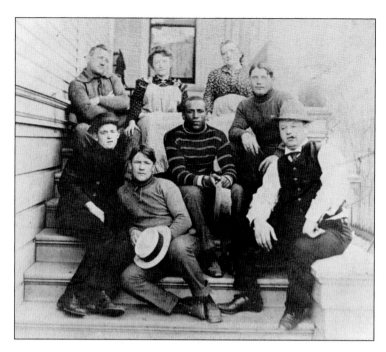

From left to right, Billy Shannon, his wife, Lena, and Lena's mother, Magdalena Stappenbeck, sit at the top of the stairs in this *c.* 1908 photograph. Surrounded by four unidentified men is Joe Gans. Gans trained at Shannon's and was the first native-born African American to win a world title. He is considered one of the greatest boxers of all time. He held the lightweight title from 1902 to 1908.

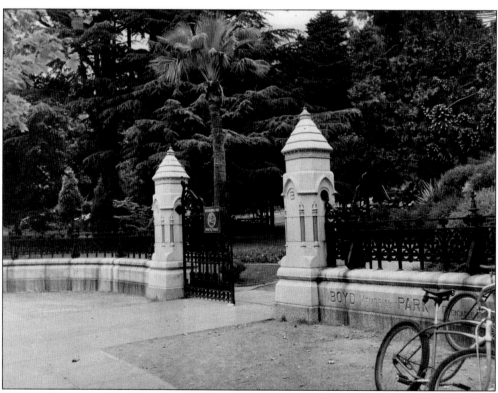

Boyd Park and the Gate House were donated to the City of San Rafael in 1905 as a memorial to the two teenage sons of John and Louise Boyd. John Boyd purchased additional property and removed homes so that the park property extended from B Street to the top of San Rafael Hill.

Ten

THE SAN PEDRO
PENINSULA

In 1853, Matthew Murphy inherited a portion of Timothy Murphy's original land grant that was the San Pedro Peninsula. Matthew, Timothy's brother, died six months later from an accidental gunshot wound. Matthew Murphy's heirs sold off the land over the next 15 years. The name that is most closely associated with the San Pedro Peninsula is McNear. John A. and George W. McNear purchased 500 acres on Point San Pedro in 1869. The brothers had settled in Petaluma, where they operated a number of different businesses. In 1874, the brothers dissolved their partnership; John McNear kept the Marin property and eventually increased his holdings to some 2,500 acres. Erskine B. McNear came to Point San Pedro when he was 14 years old to manage his father affairs there. He and his father purchased the Fortin Brick Company in 1898.

With the completion of the transcontinental railroad in 1869, many unemployed Chinese came to San Francisco in search of work. Some found their way to Point San Pedro to fish for shrimp. China Camp was one of several shrimping camps established along San Pablo Bay. The population of China Camp grew in the late 1870s and early 1880s as anti-Chinese sentiments reached their heights. The 1880 federal census lists 469 individuals at China Camp. Eventually, most of the Chinese left to find other work. In 1911, legislation was passed that prohibited the use of traditional bag nets and the exportation of dried shrimp. Only Quan Hock Quock and his family remained. Quan, who operated a small store, discovered that a new type of net worked well in the waters off China Camp. By the mid-1920s, Quan's Yick Yuen Company operated 36 motorized shrimp trawlers, each bringing in 1,000 pounds of shrimp a day. Quan's descendants continued to operate at China Camp after his death.

Approximately 2,500 acres of the San Pedro Peninsula are undeveloped and preserved as parkland in China Camp State Park, Marin Open Space District Preserves, McNear's Beach County Park, and the city's Harry A. Barbier Memorial Park.

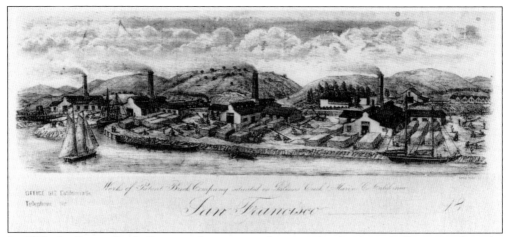

In 1870, the Patent Brick Company began manufacturing bricks along Gallinas Creek at the intersection of today's Smith Ranch Road and Silveira Parkway. Clay for the bricks came from the hills just west of the brickyard. The company produced 1.5 million bricks per month in 1915 but closed in 1918.

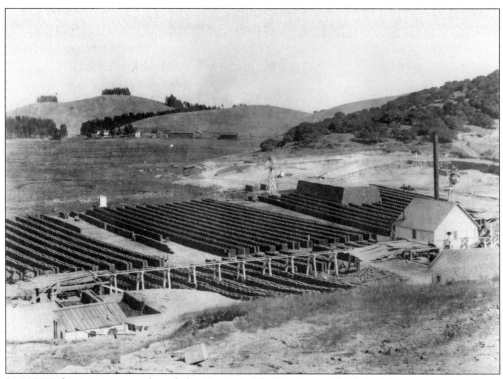

In 1898, John McNear purchased the Fortin Brick Company, which had been in operation on the point since 1885. Clay was quarried on the nearby hill. In this photograph of the brickyard, taken about the time McNear purchased it, green brick is stacked and drying in the yard. Bricks were loaded on scow schooners and shipped throughout the Bay Area.

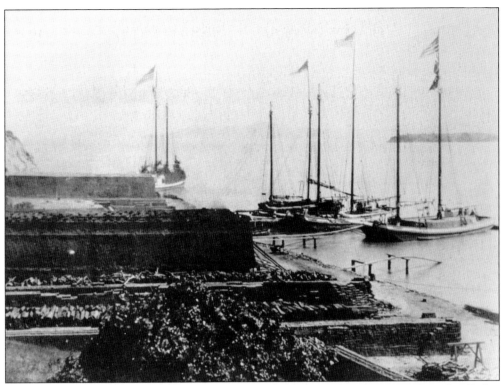

Scow schooners, shown in this 1885 photograph of the Fortin Brick Company on Point San Pedro, brought wood to fuel the early field kilns and carried brick to Bay Area destinations.

The McNear Brick Company was a large employer of northern Italian immigrants to San Rafael. Many of the men, unskilled laborers, found their first jobs at the brickyard. In this 1920s photograph, Hoffman kiln wheelers use a railcar instead of wheelbarrows to move the bricks within the kiln. Pictured from left to right are Joe Milani, James Massara, Henry Bulotti, and Carlo Vandoni.

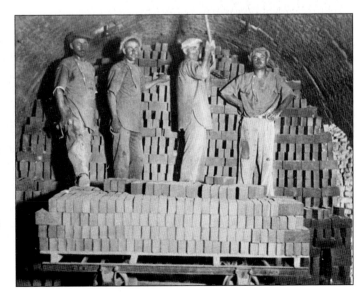

The McNears built two houses at the beach, a store, and a warehouse. The store supplied local ranchers and Chinese fisherman camped at Point San Pedro. This photograph was taken in 1899.

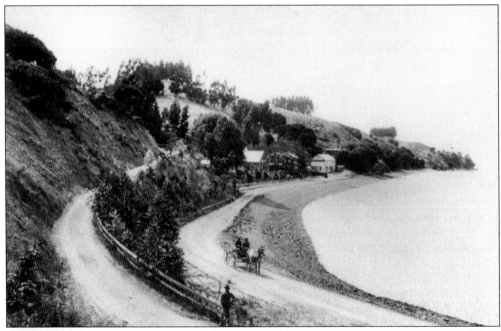

The McNears built the road from San Rafael out to the beach using Chinese laborers and then sold it to the city. The road, houses, warehouse, and beach are shown in this 1899 photograph. As the beach became a popular destination, the McNears began charging a small fee to picnic and swim. It remains a popular destination today as part of Marin County's park system.

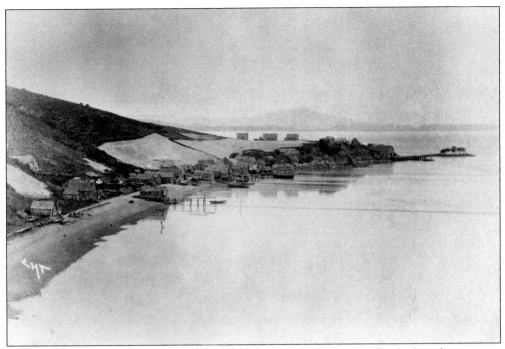

This is China Camp in 1888. In 1880, the village consisted of 469 individuals, a few stores, a teacher, and a physician. Records indicate that some of the villagers were employed in San Rafael as hotel cooks and gardeners. The shrimp were dried on the hillside (as seen in this photograph), threshed to remove the hull, winnowed, and taken to market.

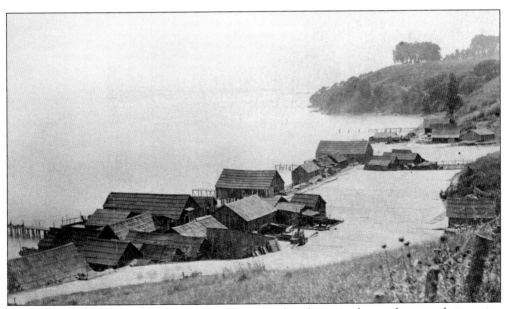

The Chinese built their houses on silts along the shoreline, similar to those in their native Guangdong Province. They terraced the hillsides behind their houses and planted vegetable gardens. Sturgeon and other fish were caught in the bay.

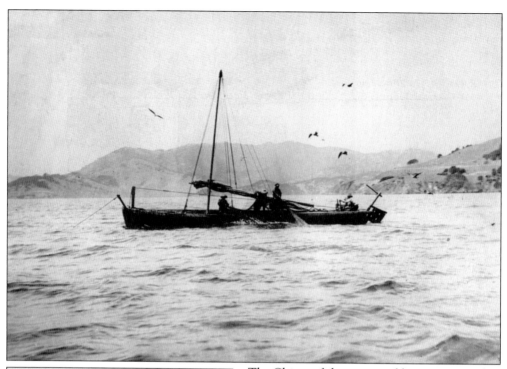

The Chinese fishermen used bag nets to catch shrimp before the nets were outlawed in 1911. The nets were set in the bay's mud. When the tide came in, the shrimp were swept into the nets, and the nets were emptied by the fishermen into traditional flat-bottomed boats.

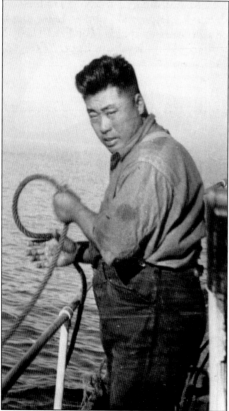

Henry Quan, shown here, continued the shrimping operation established by his father, Quan Hock Quock. After Henry Quan died in 1950, his wife, Grace, operated a snack bar and boat rental service at China Camp. Today the Quans' son Frank is China Camp's only resident.

This promotional brochure depicts the community planned by Mabry McMahan on 193 acres, which his wife had inherited from her father. In 1914, McMahan dredged and built a wall along Gallinas Creek. His grand vision of a community of homes around canals, a grand hotel, and a ferryboat dock to take residents to work in San Francisco never came to fruition. World War I halted McMahan's plan, and no homes were built until Santa Venetia was developed in the 1950s.

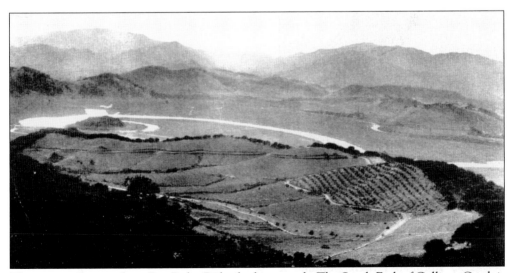

This is an early view from San Pedro Ridge looking north. The South Fork of Gallinas Creek is the wider channel. It encircles Santa Margarita Island on the left. On the smaller north channel of the creek is the Patent Brick Company.

ACROSS AMERICA, PEOPLE ARE DISCOVERING SOMETHING WONDERFUL. *THEIR HERITAGE.*

Arcadia Publishing is the leading local history publisher in the United States. With more than 4,000 titles in print and hundreds of new titles released every year, Arcadia has extensive specialized experience chronicling the history of communities and celebrating America's hidden stories, bringing to life the people, places, and events from the past. To discover the history of other communities across the nation, please visit:

www.arcadiapublishing.com

Customized search tools allow you to find regional history books about the town where you grew up, the cities where your friends and family live, the town where your parents met, or even that retirement spot you've been dreaming about.